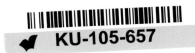

Collins

Success
with
Oils

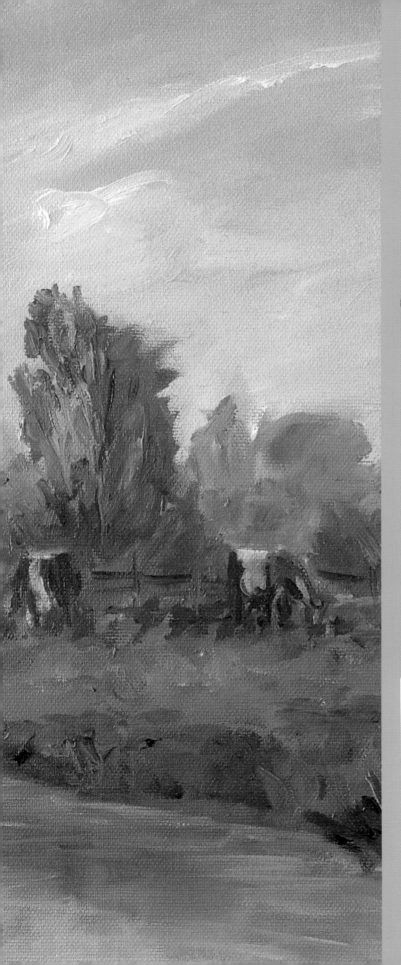

Success
with
Oils

A step-by-step guide to
dispelling the myths

Melanie
Cambridge

ACKNOWLEDGEMENTS

My thanks to Geoffrey Frankcom for encouraging me to write this book in the first place and to Cathy Gosling at HarperCollins for having confidence in me. Thanks also to Caroline Churton, Geraldine Christy, Julie Francis and Laura Knox for helping me through the production process. Finally, my grateful thanks to my husband, Peter, for his belief in me and constant encouragement over the years.

First published in 2002 by
Collins, an imprint of
HarperCollins*Publishers*
77-85 Fulham Palace Road
Hammersmith, London W6 8JB

The Collins website address is:
www.collins.co.uk

Collins is a registered trademark of
HarperCollins Publishers Limited.

06 05 04 03 02
6 5 4 3 2 1

© Melanie Cambridge, 2002

Melanie Cambridge asserts the moral right to be identified as the author of this work.

A catalogue record for this book is available from the British Library

Editor: Geraldine Christy
Designer: Julie Francis
Photographer: Laura Knox

A companion video, also entitled *Success with Oils*, is available from APV Films, 6 Alexandra Square, Chipping Norton, Oxfordshire OX7 5HL (tel: 01608 641798)

ISBN 0 00 711852 X

Colour reproduction by Colourscan, Singapore
Printed and bound by Bath Press Colour Books

PAGE 1: **High Summer**, 41 x 41 cm (16 x 16 in)
PAGES 2-3: **Evening Light, River Wey** 31 x 51 cm (12 x 20 in)
PAGES 4-5: **Towards San Gimignano** 25 x 20 cm (10 x 8 in)

Contents

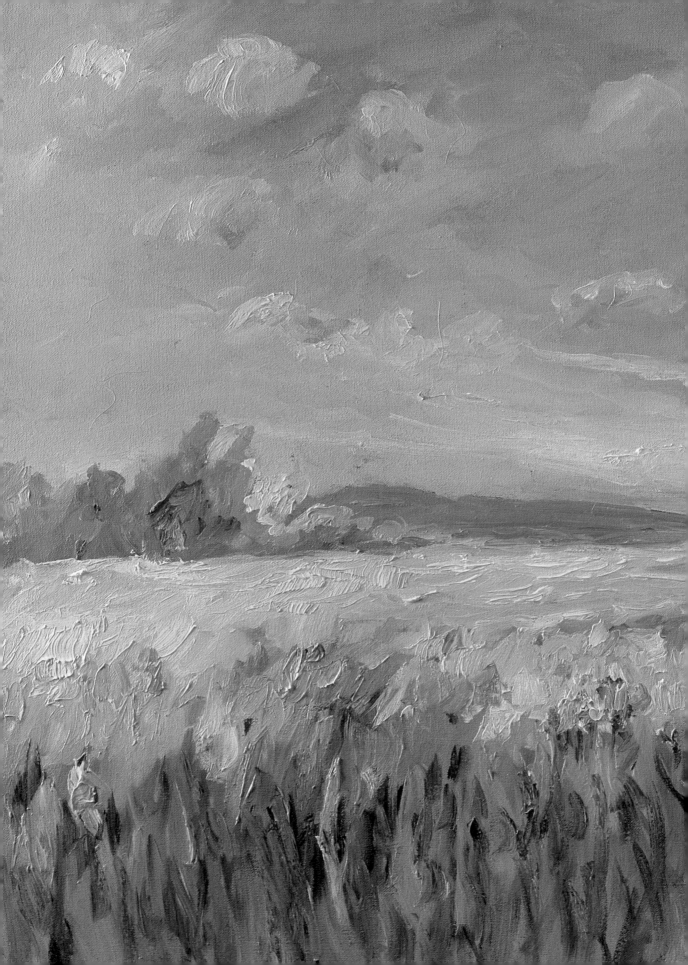

Introduction

I love painting in oils, particularly landscapes. Oil paints seem to lend themselves to landscape subjects, having both the subtlety to depict a misty river yet also the strength and vibrancy to capture the dazzling colours of the Mediterranean. The pleasure of squeezing all that colour onto a dark mahogany palette always sparks off feelings of excitement and anticipation. I find even the buttery texture of the paint alluring.

ABOUT THIS BOOK

For anyone wishing to try oils for the first time, this book offers a simplified approach to help get you started. Throughout the book examples show you how to create successful oil paintings in just one session. A variety of landscape subjects is covered, helping you to gain confidence when painting from sketches, photographs or on location. While sketches are important for gathering material and ideas, the ability to draw well is not essential for success. Many of the examples in this book are painted directly from rough, annotated sketches with no detailed pre-drawing on the canvas at all.

Each chapter introduces a specific technique or subject. More experienced students can therefore progress by looking at the elements of most interest to them; for example, how to bring paintings to life with figures – an area that many students find difficult.

I have also tried to dispel the myths that oils are difficult and messy and require a great deal of materials and space. I suggest a minimum of

▼ **The Old Church, Send**
30 x 41 cm (12 x 16 in)
This painting was produced on location in the late afternoon. The church was painted very loosely with a minimum of detail. I worked quickly with a No. 8 flat brush to create the rough meadow in the foreground. Notice how the addition of Alizarin Crimson warms this area, so helping to bring it forward visually.

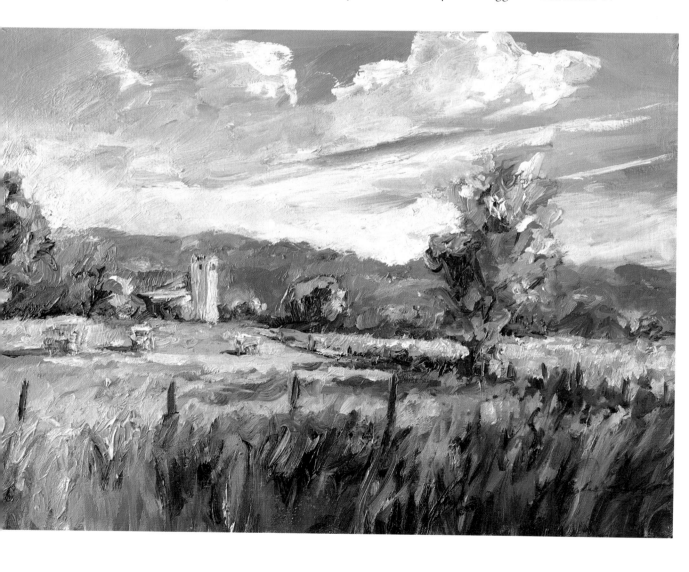

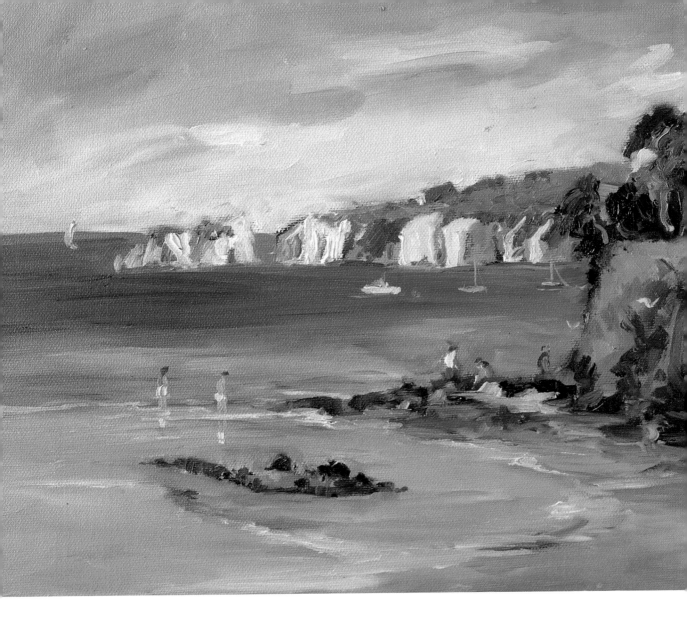

Low Tide, Studland
25 x 31 cm (10 x 12 in)
I painted this scene sitting on the cliffs with a pochade box balanced on my knees. The box held just a few colours, two brushes and a little alkyd medium.

equipment, gel mediums and soap brush cleaners, all of which will enable you to work comfortably indoors without any of the usual associated fumes and other expected drawbacks.

It is my experience that people learn first of all by copying, so most sections of this book are accompanied by a step-by-step demonstration. These will take you through each stage of the painting so that you can fully understand how the painting develops from the initial idea to the finished work. Details are included alongside certain stages to highlight a particular technique or point of interest. You will also find various short exercises to follow. Again these are there to help get you started – I hope you will find them fun to do as well as helping you to understand a particular technique.

You will find also find Tips boxes. These are intended to draw your attention to points about working methods and also to offer simple solutions to everyday painting problems. As I cannot be with you at each stage, I hope you will find my comments and suggestions useful.

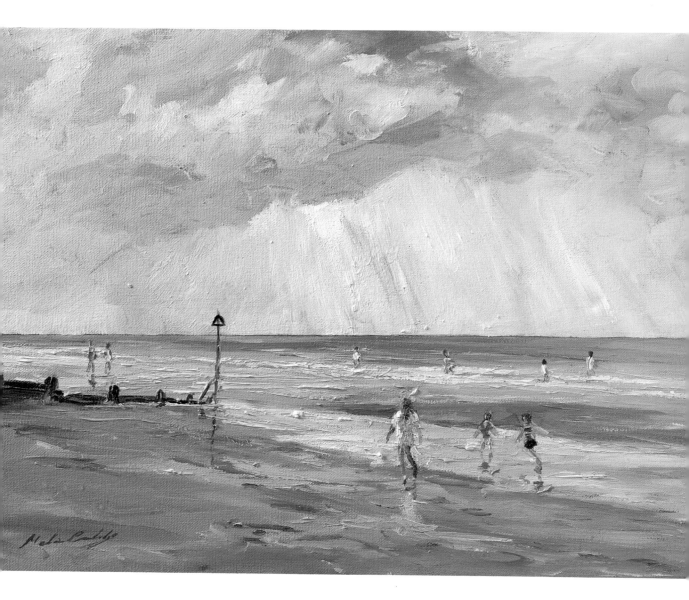

▲ **Low Tide at Camber Sands**

28 x 36 cm (11 x 14 in)
The key to this painting is its atmospheric sky. The figures were captured with just a few brushstrokes as they played in the tidal pools.

OILS – A FORGIVING MEDIUM

The real magic of oil paints comes from their versatility. In the last two centuries artists have used oils to create all sorts of different painting styles, from the almost photographic qualities produced by painters such as the Pre-Raphaelites, to the looser work of the Impressionists and on to Cubism and other forms of abstraction. There is also a range of textures possible with oil paints. Colours can be thinned down to a wash-like consistency, blended to a smooth finish or applied roughly, leaving brushmarks clearly visible. Indeed, the brushmark is probably just as important an element in contemporary oil painting as the colour used. This emphasis on individual brushmarks in oil painting makes it much easier for the beginner. Solid brushmarks can be used to 'build' a figure, boat or house without drawing an initial outline. Look at how Paul Cézanne

(1839–1906) experimented with brushmarks, using them to create blocks of colour to create shape.

While some ability to sketch is important for all types of painting, drawing tends, by its very nature, to be based around the use of lines and outlines. For landscape painting, however, the outline is not always the most important factor. Perhaps more essential is the ability to 'see' areas of colour and tone and to learn to place them on the canvas appropriately to 'build' the finished painting. Throughout this book I have tried to teach you how to create a painting by 'building'. Oils, being an opaque medium, are ideal for use in this way. Large areas of solid colour can be established early on in the painting process to create the overall composition, with details being added later on. However, because oils dry slowly – over several days or more – there is plenty of time to alter an oil painting or even scrape off areas of colour and start again. This takes away some of the pressure of getting everything right first time – a great advantage for the beginner and more experienced artist alike!

With such a forgiving and exciting medium, oils can offer so much to the beginner – so what are you waiting for? Let us make a start.

▼ **Dusk**
31 x 51 cm (12 x 20 in)
Note how the brushmarks themselves create the textures and shapes of the main tree as well as.the flower heads in the darkening meadow. I did almost no pre-drawing, concentrating instead on the way the colours and tones relate to each other.

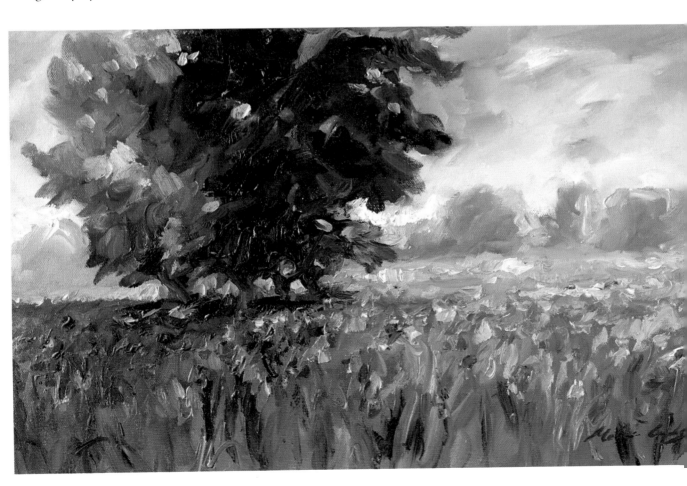

Materials and Equipment

A bewildering amount of equipment faces the beginner visiting an art shop. This, and the false idea that oils are 'smelly' and 'difficult', requiring specialist thinners such as turpentine, linseed oil and stand oil, is enough to put anyone off! All you need to start, however, are just a few colours, three or four brushes and an odourless gel for thinning the paints.

◀ Melanie's working palette loaded with fresh paint.

COLOURS

Oil paint comes in tubes and is normally available in two different grades, artists' quality and students' quality. Artists' quality paints are slightly more expensive, but the difference in quality of pigment is considerable. As you will only be working with a few colours, they are well worth the extra cost. Tubes of varying sizes are available and 38 ml tubes are a suitable size to begin with, but do invest in a larger tube of Titanium White, say 60 ml. Unlike watercolours, oils are an opaque medium and need the addition of white to create the paler tints. Thus you will tend to use much more white paint in proportion to any of the other colours.

As well as traditional oils, there are also various 'special oils' on the market, including water-mixable oils and alkyd paints, which are faster drying.

The basic palette

You need only a basic palette of eight colours, plus white, to start. This should comprise two blues, two yellows, two orange shades, one red and one green.

The blues I suggest are French Ultramarine and Coeruleum. Choose Lemon Yellow and Raw Sienna for your two yellows. The orange shades I suggest are Cadmium Orange and Light Red. Alizarin Crimson is a useful red and Viridian makes a good base green. These eight colours should enable you to mix all the colours you will need for landscape painting.

I also recommend Titanium White as it is a very bright, opaque white.

I do not use black. Having it available on the palette makes it too tempting to darken a colour simply by adding black and its addition can make colours dull and lifeless. Instead, try mixing French

▼ Basic colour palette

French Ultramarine
A deep warm blue and a good all-round colour.

Coeruleum
A cold turquoise blue, useful for skies and making wonderful greys.

Lemon Yellow
A cold bright yellow, excellent for mixing spring greens.

Raw Sienna
A warm earthy yellow, useful for producing warm greens and browns.

Cadmium Orange
A bright orange for mixing warm greys and cloud tones.

Light Red
A brownish orange for making dark tones and greens.

Alizarin Crimson
A dark red that produces strong purples and dark greens.

Viridian
A very strong green, excellent for mixing, but not for use on its own.

Ultramarine and Light Red for your darkest tones. These two colours make very lively darks and are far preferable to black for landscape painting.

Additional colours

Once you begin to feel confident working with the basic palette of eight colours you may wish to add a few more. The following colours are the ones I find to be useful additions from time to time: Naples Yellow, Cadmium Yellow Deep, Rose Madder, Raw Umber, Cobalt Blue and Sap Green.

BRUSHES

Oil brushes are traditionally made from hog hair. However, there are a number of excellent synthetic oil brushes on the market. Rather than have a large number of brushes, start off with four or five, plus a palette knife (for mixing colours on the palette and occasionally scraping paint off the canvas).

I recommend that you start with five brushes. A No. 10 (25 mm or 1 in) short flat nylon brush is ideal for blocking in large areas of colour to establish the main structure of the painting. A No. 8 (16 mm or ⅝ in) short flat nylon brush is my most useful brush as it is capable both of blocking in medium areas of colour, yet still useful for moderate detail work. A smaller No. 4 (10 mm or ⅜ in) short flat nylon is used for details and the basic shapes of buildings. I also use two round nylon brushes: a No. 4 round as a basic fine detail brush, and a No. 4 rigger, which is ideal for painting branches and very fine lines.

▼ Additional colours

Naples Yellow
A warm cream tone.

Cadmium Yellow Deep
A bright orange yellow useful for painting sunflowers and cornfields.

Rose Madder
A deep pink that gives warmer purples and greys.

Raw Umber
A soft brown.

Cobalt Blue
A bright blue, makes a useful addition for skies.

Sap Green
A warm olive green shade.

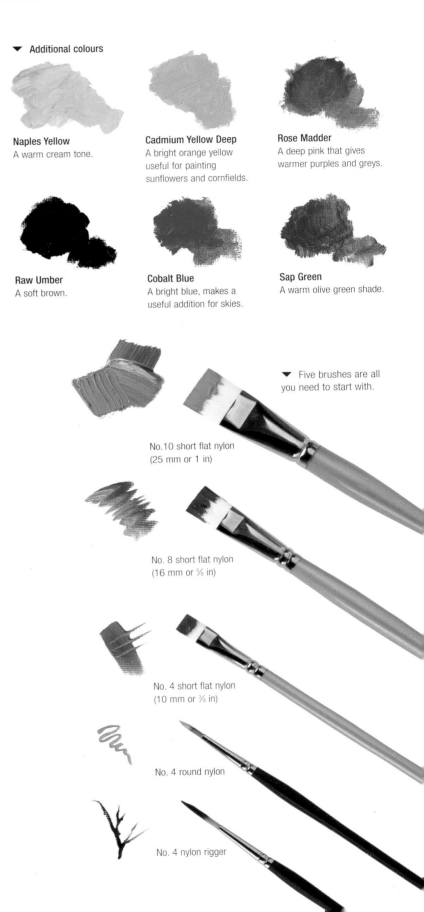

▼ Five brushes are all you need to start with.

No.10 short flat nylon
(25 mm or 1 in)

No. 8 short flat nylon
(16 mm or ⅝ in)

No. 4 short flat nylon
(10 mm or ⅜ in)

No. 4 round nylon

No. 4 nylon rigger

▶ A selection of painting surfaces and other basic materials.

PAINTING SURFACES

Oil paints can be used on a number of different surfaces. The traditional surface is stretched cotton or linen canvas, but canvas boards and oil sketching paper are acceptable alternatives and are less expensive. Offcuts of mounting board or even cardboard can make useful surfaces for a quick sketch, although they are not ideal for a full painting.

It is possible to buy canvases ready primed and stretched onto a frame. These come packaged with a set of wedges. Knock each wedge into the corner of the canvas at the back to tighten up the surface until it is 'drum tight' and ready to paint on. Canvas boards probably make the best support for finished paintings as they are less expensive than a stretched panel, but still provide a woven textured surface.

MEDIUMS AND THINNERS

Oils are traditionally used alongside a number of highly toxic mediums and thinners, including turpentine, linseed oil and stand oil. To simplify matters, however, and to avoid the fumes associated with these products, I use an alkyd gel medium. Alkyd mediums are generally odourless and therefore ideal for use indoors. They also speed up the drying process, cutting it almost in half, so that even traditional oils can be touch-dry in three to four hours.

For cleaning brushes, try using white spirit. This is less harmful than turpentine and has a less pronounced smell. Remember to keep a lid on the white spirit while working, however, to avoid inhaling any fumes. It is also possible to clean brushes using a special soap cleaner or brush-restorer. This is a more expensive option, but it works well and is very useful when painting abroad.

While painting, keep plenty of rags handy and wipe off excess paint from the brushes as you go along, rather than cleaning your brush completely every time you change colour.

PALETTES

Palettes, made of wood or plastic, come in many sizes, and are normally kidney shaped or oblong. Experiment to find one that has enough space to mix colours on but is not too heavy to hold in one hand. It is also possible to use a sheet of glass or 'tear-off' palette sheets.

Most of the exercises in this book are produced on an earth-coloured ground rather than white canvas. The colour of a wooden palette is similar to the coloured canvas, so for this reason I recommend a wooden rather than a plastic palette to begin with. This will allow you to match the colours visually more easily.

EASELS

When painting with oils it is preferable to have the canvas fairly upright and the easiest way to achieve this is by using an easel. This could be anything from a simple wooden sketching easel or a full-

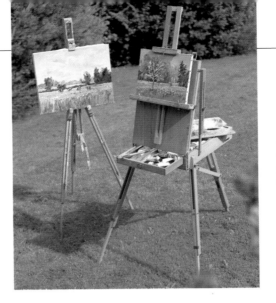

◀ A portable easel keeps the canvas in an upright position and enables you to stand back from the painting while working. Finished oil paintings are generally viewed from about 2 m (6 ft) away, so it is helpful to be able to take a step back from your work to see how it will appear when seen from this distance.

sized studio one. If space at home is at a premium a box easel may be the answer as this will both hold all your equipment and fold away for easy storage. However, a full-sized box easel weighs around 3 kg (6 lb) empty and considerably more when filled with tubes of paint etc.

WORKING OUTDOORS

If you intend to paint mainly outdoors a pochade box makes a useful addition to your equipment. I would not suggest one as a replacement for an easel, but it is ideal for working outside and enables you to sit or stand in a quiet corner and work relatively unobserved by passers-by. It can even be used sitting in the car.

▼ A pochade box incorporates a small pull-out palette, tubes of paint and brushes, with space in its lid for two or three small canvas boards (often only 18 x 13 cm/7 x 5 in or 25 x 20 cm/10 x 8 in in size) at most.

to sum up

Oil painting equipment can be kept to a minimum. To start off you will need:

8 oil colours, plus white
5 brushes
1 palette knife
wooden palette
single dipper (clips onto the palette to hold gel medium)
gel medium
jar of white spirit or tin of soap brush cleaner
plenty of rags
a suitable easel or table stand

Getting Started

Having decided what equipment is really essential, it is now time to start painting. But where to begin? It is essential to start off by really getting to know how to use your oil paints and discovering how many different effects can be created. This section will guide you through basic techniques as well as mixing colours and getting to grips with tones.

◀ **The Olive Grove**
20 x 25 cm (8 x 10 in)

GETTING TO KNOW OIL PAINT

In order to help you get a 'feel' for oil paints, take a medium sheet of sketching paper and simply play with the paint. Try to make as many different marks as possible. This may seem silly at first, but it is probably the best way to start as you will not be under any pressure to produce a painting, just a series of marks and experiments. Apply the paint thinly with plenty of gel medium mixed in; try adding another colour on top – use thicker paint; draw fine lines with the rigger brush; try to create 'lively' brushstrokes, working a No. 4 flat brush in different directions every time you touch the canvas; even scratch through an area of thicker paint.

▼ When you first start painting with oils try to make as many marks as possible. These doodles do not make any sense; they were just fun to do.

As you will see, there are many different ways to create marks with oil paint. Also, oil paint can actually 'feel' different depending on how it is used; for example, when thinned down with gel medium it is smooth and glossy, but used straight from the tube it is much more 'sticky' in texture.

BASIC TECHNIQUES

Once you have tried experimenting with oil paint, try some of the following basic techniques. A technique is really only a specific way of applying paint to canvas. The techniques shown here are some of the more common methods used for applying oil paint. Practise them until you are confident in handling oil paint and can achieve the effect you want.

Scumbling

Scumbling is a useful way of creating an area of broken colour. The paint is applied fairly thinly and using a 'dry brush' (not dipped in thinner first of all) so that patches of the canvas or underlying colour show through the scumbled top layer. This technique can be helpful in toning down an area of colour that appears too strong or dark. A light blue shade can be scumbled over the top of the dry distant hillside to make it appear more distant in the painting.

Blocking in

In order to establish the main areas at an early stage in the painting the larger shapes are 'blocked in' with flat areas of solid colour. Paint is applied with even brushstrokes, using slightly thinned-down paint, to establish these opaque areas of colour.

Stippling

Another technique for creating areas of broken colour. Paint is dabbed onto the canvas, often on top of another dry colour. Stippling can add texture and also break up a large flat area of colour; for example, patches of red stippled onto a field of corn can create the appearance of poppies in the middle distance.

Impasto

Paint is applied thickly using random brushstrokes to create a textured effect. Highlights in the sky and on the edges of buildings are areas where impasto is a useful tool. Heavily painted highlights stand out much better against the rest of the painting, giving them much more emphasis than areas of dark tone.

Brushstrokes

While not strictly a technique, the mark made by the brush in oil painting is a key element. For example, when painting a figure or animal a single brushstroke can be used for the arm or leg. Also, the brushstroke itself makes a textural mark in the paint, creating a more interesting surface than blended colour. When painting skies, these brushstrokes can be used in a pattern to help create the cloud shapes and give a sense of movement.

Random lines

Use random lines to add branches and other linear details over wet paint. Dragging a rigger brush through the wet underpainting picks up a little of the underlying colour, blending in and creating a very natural effect.

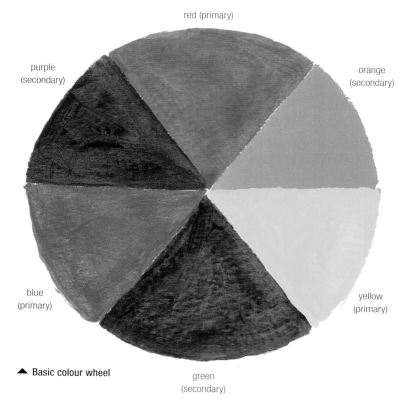

red (primary)

orange (secondary)

purple (secondary)

yellow (primary)

blue (primary)

green (secondary)

▲ Basic colour wheel

▶ Pairs of complementary colours

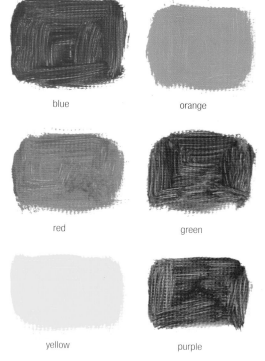

blue

orange

red

green

yellow

purple

MIXING COLOURS

Colour theory sounds a dry subject, so it is tempting to skip over this section. However, learning how colours work is important in painting. By keeping to simple guidelines I hope you will find mixing colours interesting and easy to understand.

Most students remember the basic colour wheel that shows the three primary and secondary colours.

Colours that are opposite each other on the wheel are termed complementary. Therefore blue and orange are complementary to each other, as are yellow and purple, and red and green. Colours that are complementary will make grey when they are mixed together in equal portions. Therefore, if you add a little orange into blue it will 'grey down' the blue, making it slightly darker, softer and duller. This is a very useful technique for landscape painting. That is all you really need to remember about colour theory. The secret lies in understanding how to use this knowledge when mixing colours.

Darker shades and shadow colours

We can use this knowledge of complementary colours to make darker shades and shadow tones rather than simply adding black. Just a very small amount of a colour's complementary will darken it in tone considerably. For example, a touch of Viridian added to Alizarin Crimson will produce a dark or dull red. Similarly, a touch of Alizarin Crimson added to Viridian will darken or dull the green. Try this for yourself and

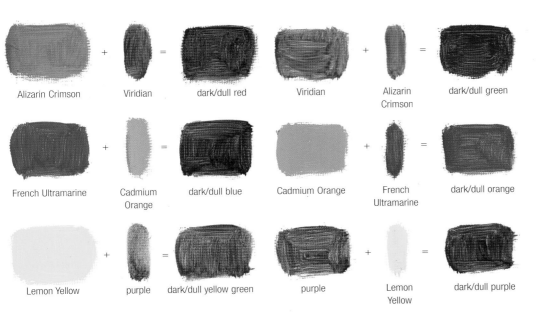

Alizarin Crimson	+	Viridian	=	dark/dull red		Viridian	+	Alizarin Crimson	=	dark/dull green
French Ultramarine	+	Cadmium Orange	=	dark/dull blue		Cadmium Orange	+	French Ultramarine	=	dark/dull orange
Lemon Yellow	+	purple	=	dark/dull yellow green		purple	+	Lemon Yellow	=	dark/dull purple

◀ **Adding the complementary colour**

▼ **Padstow Boatyard**
18 x 13 cm (7 x 5 in)
The main shadow tones have been painted using a combination of complementary blue and orange (with some white) to achieve a subtle range of greys and darker tones.

then with other complementary pairs of colours. Being able to darken a colour in this way without making it appear dirty helps to keep the whole painting alive with clean colours and avoids the tendency to create 'mud'.

Putting theory into practice

As you start to mix darker shades with more confidence you will tend to use them more. For example, when painting trees, use your chosen green for the lighter side of the tree and indicate the shadow side by darkening the green with a little red. When painting figures, using a darker shade on one side can help give form; for instance, a little blue purple added to the mix for a yellow jacket and used on one side would give some shape to the figure. Similarly, boats which are sometimes brightly painted still need a shadow side; a little orange mixed into a bright blue for the hull darkens it to give shape to the bottom of the boat.

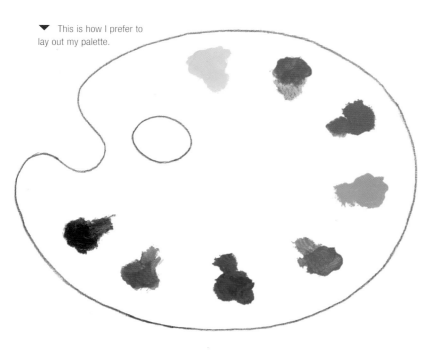

▼ This is how I prefer to lay out my palette.

MIXING COLOURFUL GREYS

When painting landscapes, greys and soft blues are constantly required, not only for skies but also to indicate background hills and create a feeling of space and distance. By using just four colours, two blues and two orange shades, with the addition of some white, you will be able to mix a whole range of subtle grey tones. I am always mixing grey tones and I find it most helpful to place the key colours that I use alongside each other on my palette.

Start off by placing your colours in the same order on the palette as shown here, with the two blues and two orange shades next to each other in the centre of the palette. This will create a 'key mixing zone', essentially a simple reminder for mixing grey tones, so important for landscape painting.

Try mixing a series of greys for yourself. Start off using only Cadmium Orange, first with Coeruleum, then with French Ultramarine. This brighter orange colour makes a 'clean' grey when mixed with blue. Then repeat the exercise using Light Red in place of Cadmium Orange. The greys will be much stronger and also may appear a little muddy, particularly if you add too much Light Red. Adding white to your mixtures will considerably increase the range of greys.

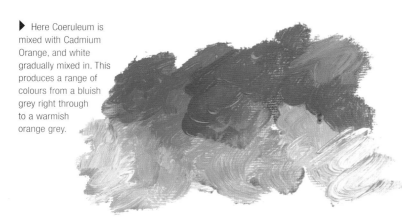

▶ Here Coeruleum is mixed with Cadmium Orange, and white gradually mixed in. This produces a range of colours from a bluish grey right through to a warmish orange grey.

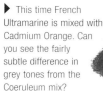

▶ This time French Ultramarine is mixed with Cadmium Orange. Can you see the fairly subtle difference in grey tones from the Coeruleum mix?

COPING WITH GREENS

Green is everywhere in the landscape and, as an artist, it is very easy to be overwhelmed by it. However, as with all colours, green is usually tinged with another colour; for instance, it may be a

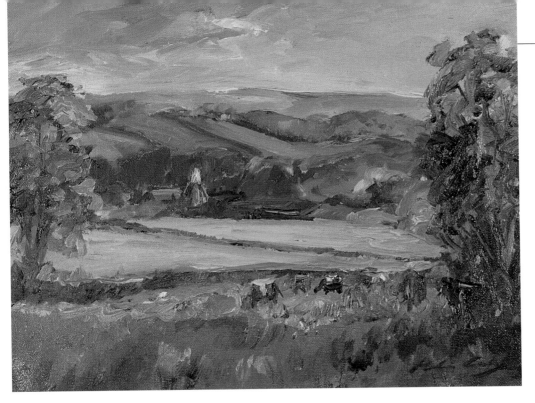

◀ Across the Kentish Weald
Across the Kentish Weald
28 x 36 cm (11 x 14 in)
In this view over the Kentish Weald on a wet, grey day when all the greens looked much the same, differences have been exaggerated to create a feeling of recession, using stronger tones in the foreground and much bluer shades towards the distant hills.

reddish green shade or a bright lime green or even have a warm ochre undertone. So, when you start to mix greens, try to be aware of the differences within the colour rather than regarding every tree, field or bush as simply 'green'. Ask yourself 'what sort of green is it?' and you will see these differences. When painting, exaggerate the variations to keep the whole painting alive and to avoid a flat look that tends to happen if you use only one or two shades of green.

Using Viridian

In principle, mixing blue and yellow makes green. Mixes of Coeruleum and Lemon Yellow produce a range of bright greens, but not all blues and yellows make good green shades. So, I suggest you try mixing greens using Viridian as a base colour. On its own, Viridian looks strong and unnatural, but when mixed with either of the two yellows, or orange, or even its complementary, red, a whole range of natural tones can be created.

exercise

Look carefully at the greens in the landscape – how many different shades can you really see? Make quick sketches and note down the tones on different areas of the sketch; for instance, whether one tree is reddish in tone or more ochre coloured.

Lemon Yellow added

Raw Sienna added

◀ Using Viridian as a base green

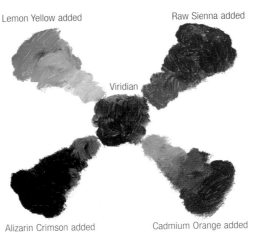

Viridian

Alizarin Crimson added

Cadmium Orange added

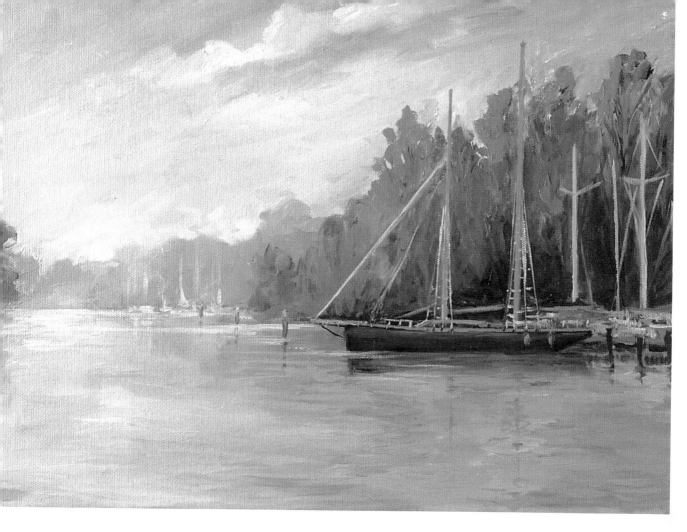

▲ Quiet Moorings, River Hamble

31 x 41 cm (12 x 16 in)
On a misty morning it is easier to judge tones than on a bright sunny day because the atmosphere intervenes and simplifies matters. Distant trees appear as simple shapes, and even foreground features lose some detail, making it easier to judge their relative tonal value.

▼ A simple tonal scale from black to white

WHAT IS TONE?

Every colour has a range of tones from its brightest version to its darkest, and the tonal value of a colour is simply its relative lightness or darkness. The term tonal values within a painting refers to the overall range of lights to darks in the composition. Before you start a painting it is essential to sort out what is the lightest area and how light is it? Similarly what is the darkest area and how dark is it? Every other colour in the painting will fall somewhere in between these two extremes of light and dark.

To help you assess the tone of a colour, make a simple tonal scale using black and white paint. Start with pure black and gradually add white until you reach pure white. Try to have at least six different stages in between. Keep this scale beside you as a reminder while you are painting.

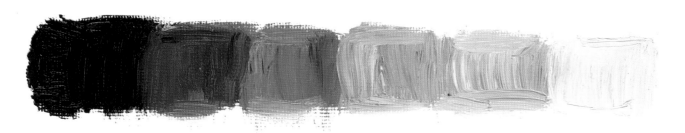

Tonal sketches

Tonal sketches are a simple way to begin to understand tones. Making a tonal sketch is, in effect, painting in monochrome. One way in which to practise how to recognize and achieve these variations in tone is to make sketches from photographs. You will need to look carefully at your photographs to decide not only which areas are dark and which light, but also how light or how dark they are. In the two examples I have painted here I have used French Ultramarine and a little Raw Sienna for the warmer light tones, but the overall effect is the same as if I had used just one colour.

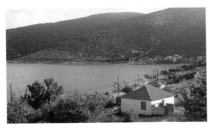
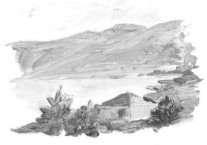

▲ The photograph of Kefallonia appears fairly flat, but notice that the background mountain is, in fact, slightly darker than the one in front of it. The sky and water are almost the same tone, while the lighter side of the foreground house is the lightest part of the whole picture.

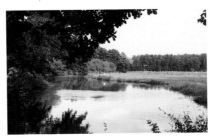
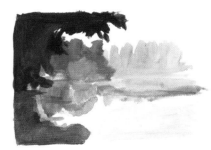

▲ A tonal sketch is particularly useful for a subject containing many different greens. In this photograph the furthest trees are palest in tone, while the foreground branches are the darkest.

exercise

Use these photographs to create your own tonal sketches. Keep to a small scale, say 10 x 15 cm (4 x 6 in) maximum, and try to work fairly quickly, giving yourself about 15 minutes for each one. Then try some quick tonal sketches of your own photographs.

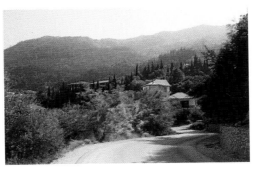

▲ When sketching this hillside scene in Lefkas, Greece, take care to ensure that there is a difference in tonal value between the middle-ground fir trees and the distant hill.

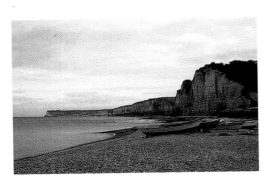

▲ This photograph of the cliffs near Etretat in France was taken on a particularly dull day. The camera shows the cliff as one tone. However, the further cliffs should appear much lighter in tone, otherwise all sense of distance is lost.

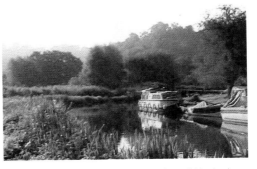

▲ A misty morning on the River Wey shows fairly clearly the tonal contrasts from the distant trees to the foreground riverbank.

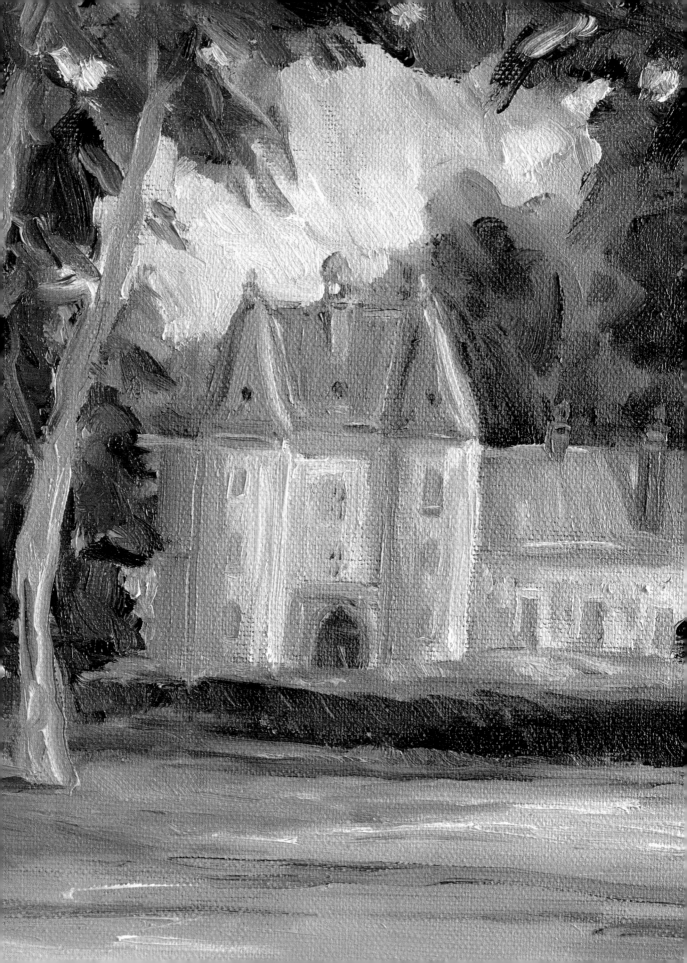

Simplifying Composition

Composition and perspective are probably two of the most unpopular aspects of painting! They can strike fear in the beginner and even more experienced artists can become confused when trying to understand the finer points of linear perspective. Since this is a book about landscape painting, I have tried to suggest basic guidelines for you to follow rather than too much detail and theory.

◀ **Loire Château**
25 x 31 cm (10 x 12 in)

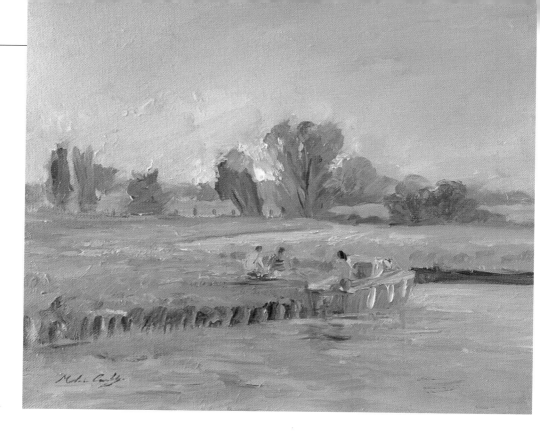

▶ **Picnic on the Wey**
25 x 31 cm (10 x 12 in)
Here the basic 'S' shape of
the river leads the eye into
the painting. The boat,
which is the centre of
interest, is placed on the
bottom-right intersection
following the 'rule of thirds'.

SIMPLE GUIDELINES

Composition is simply the arrangement
of shapes within a painting in order to
create an appealing and well-balanced
picture. These main shapes are often
used to guide the eye of the viewer to
one point in the picture – the focal point
or main point of interest. This sounds
fairly easy, and it should be, provided
you are aware of some basic guidelines.
First of all, try to avoid placing the
horizon line exactly halfway up the
canvas. This will divide the painting in
two and immediately sets off a conflict in
the composition. Any other division of
the canvas should avoid this problem.
Secondly, try to avoid placing the main
point of interest in the absolute centre of
the picture. A central point of interest
makes for a very dull composition.

Rule of thirds

Another useful guideline is the 'rule of
thirds'. Divide up the canvas into
sections, using both horizontal and
vertical lines. Placing the main point of
interest at one of the four junction
points on the canvas helps create a
balanced structure to the painting.
Similarly, placing the horizon on one of
the two horizontal lines – that is, either
one third from the top or bottom of the
canvas – will also form the basis for a
good composition.

Point of interest at one of
the four junction points.

▲ **'L'-shape**
A strong vertical on one side of the picture, with a strong horizontal foreground. The main point of interest usually occurs within the angle.

▲ **Diagonal**
A diagonal line running across the canvas can look very effective. However, make sure it creates an interesting shape and divides the canvas into two uneven parts.

▲ **Tunnel**
A tunnel or 'O' shape is often found in nature where trees overhang. Similar shapes can be seen in townscapes; for instance, through an archway or window. Take care to place both the 'O' shape and main interest off centre to avoid symmetry.

▲ **Radiating lines**
A line of fencing, buildings or even rows of lavender can be used to guide the eye towards the main point of interest.

▲ **Group**
With a group of figures, boats or even trees as the main subject, the group can be placed off centre, perhaps along one of the lines dividing the canvas following the 'rule of thirds'.

▲ **'S'-shape**
A road or river can be used to lead the eye through the painting to the main point of interest.

Basic compositional shapes

Any number of different compositional shapes can be used to lead the eye to a focal point to make an interesting picture. A few compositional shapes are shown above to get you started.

Using a viewfinder

Finding potential compositional shapes in the landscape is not always obvious. A simple viewfinder will help you to plan your compositions. Cut two 'L'-shaped pieces of card and hold them together to make a frame; they can be moved to match the proportions of your canvas.

Start by holding the viewfinder at arm's length in front of your subject – for example, the local church. The viewfinder cuts out much of the surrounding scene, enabling you to concentrate on the church itself. As you bring the viewfinder nearer to your eye, so the scene within it increases, taking in more of the neighbouring countryside. Once you have decided on your view, note any features on the edge and paint from, say, the tree on the left to the bush on the right. These key marker points will mean you do not need to constantly refer to the viewfinder.

POTENTIAL PITFALLS

It can be very tempting to include every feature in front of you, even when it detracts from the overall effect. For example, if there is an ugly water tower on the left, leave it out. Similarly with trees and other natural objects, it can be much better to keep just the main examples and leave out those that do not add anything to the overall composition.

GETTING EVERYTHING IN PERSPECTIVE

For the purposes of landscape painting the key starting point for correct perspective is the horizon line or eye level. To find eye level, hold your arm full stretch in front of you with your thumb pointing upwards. Look past the top of your thumb into the distance – you are looking at eye level. The term 'vanishing point' is used to describe the place on the eye line where two parallel lines (such as tramlines) appear to converge in the far distance.

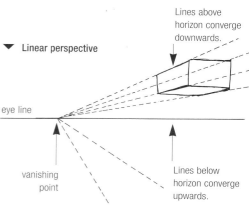

▼ Linear perspective

Lines above horizon converge downwards.

eye line

vanishing point

Lines below horizon converge upwards.

▲ ▶ **Tree Felling, Ripley**
25 x 31 cm (10 x 12 in)
In this view of tree felling near the River Wey I decided to leave out the farmhouse on the far right as this was at the very edge of the view and would have led the eye out of the painting rather than keeping it within the 'L'-shape framework of the composition.

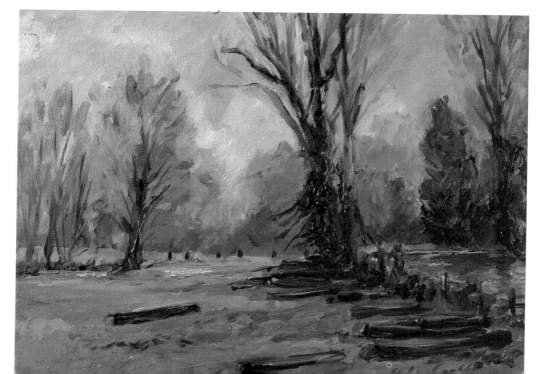

◀ **The Road to St Hilaire la Plaud**
25 x 31 cm (10 x 12 in)
In this painting of a scene in France the top edges of the trees are well above the horizon line, but if you were to take a line along these edges it would converge downwards towards the horizon line. Similarly, a line linking the bases of the tree trunks (which are well below the horizon line) converges upwards.

When you draw the horizon onto your canvas it stands in place of the eye line. Above this horizon horizontal lines converge downwards to the vanishing point, but horizontal lines below the horizon will appear to rise up to the vanishing point.

AERIAL PERSPECTIVE

Just as important to the artist is the way in which the intervening atmosphere affects the colours you see in the landscape. The further away you are from a subject, the more atmosphere there will be between you and the subject, hence the greater the effect of the atmosphere on the colours before you. This is known as aerial perspective. Colours recede in strength towards the horizon, becoming not only paler but considerably bluer. Detail is also much less – you cannot see individual branches when you are several miles away!

This effect of intervening atmosphere is most obvious on a misty or foggy day.

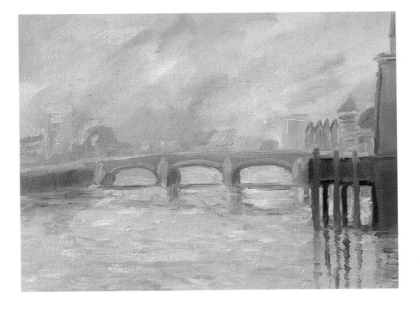

▲ **Chelsea Reach**
13 x 18 cm (5 x 7 in)
In misty conditions even complex subjects are reduced to a series of simple shapes.

Distant trees or hills may disappear completely into the mist and even middle distance trees appear much paler and with far less colour than on a clear day. The key point to remember here is that the atmosphere still has a subtle effect even on a sunny day and it is essential as an artist that you are both aware of this and exaggerate its effect in your paintings.

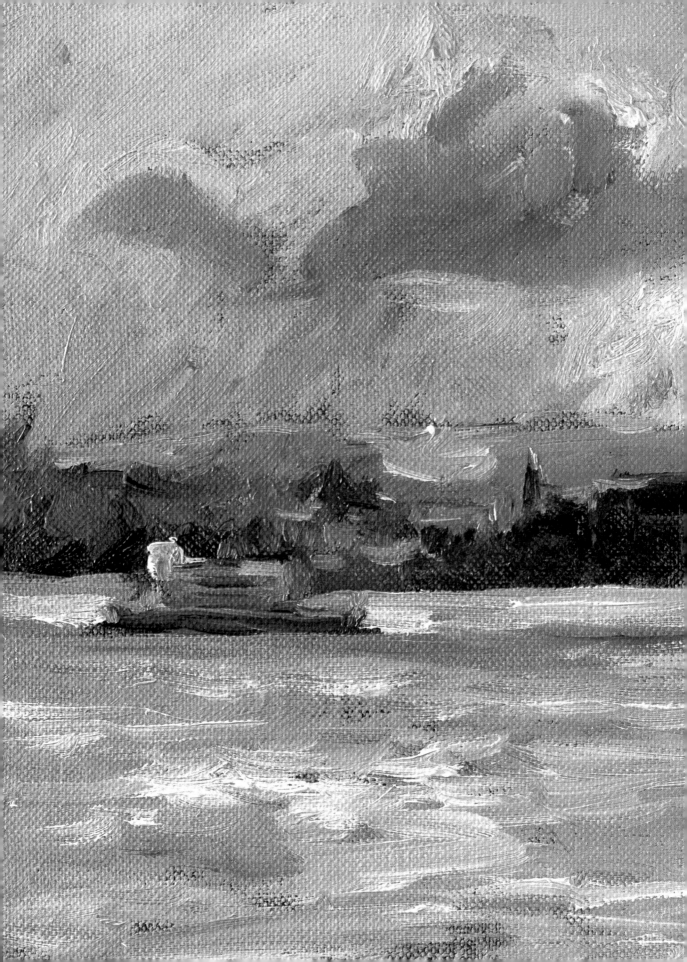

Skies and Clouds

The sky dictates the mood of a painting and all the other elements in the scene should relate back to the sky. Oil paint is an excellent medium for skies as the soft edges of clouds can be created with a brush or the finger, while the highlights on the defined top edges of larger clouds can be emphasized with thicker paint applied with a knife.

◀ **Passing Shower, Isle of Wight**
20 x 25 cm (8 x 10 in)

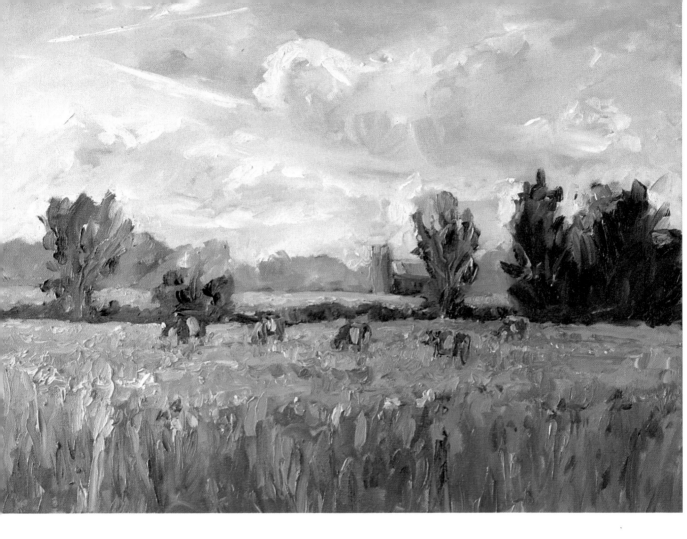

▲ Watermeadows, Send Marsh

41 x 51 cm (16 x 20 in)
For this painting I tinted the canvas with Burnt Sienna to give it a warm orange tone. Small patches of the underpainting can be seen in both the meadow and sky. The effect under the pale blue colours of the sky is particularly successful.

USING A COLOURED GROUND

Now it is time to start painting for real. The first consideration is whether to work on a white or coloured background. I rarely paint onto a white background because this makes it much more difficult to judge the lightest tones – white paint does not show up on white canvas. Having a medium-toned surface instead enables you to judge the lightest and darkest tones straightaway.

Part of the joy of oil painting is the range of textures possible, and even leaving a little of the underlying canvas to show through can be very effective. If this painting surface is white, it rarely adds anything to the finished painting.

However, if you start with a thin wash of Burnt Sienna or a mix of Coeruleum and Cadmium Orange, allowing these to dry thoroughly first, then this warm tone has a subtle effect on the finished painting, particularly the sky.

In watercolour the sky is usually the first area to be painted using large washes, but this is not always possible with oils and you will need to decide whether to paint the sky first, leaving space for any trees or buildings, or to paint the sky last and work up to the background shapes. Unless the sky is the most predominant area of the painting, for example, where the horizon line is very low, then I would recommend painting the sky last.

LIGHT SOURCE

An easy mistake to make when painting is to have more than one light source. When sketching, I often put an arrow on the sketch indicating the direction of light. On the actual painting mark in all the shadow areas in blue and the highlights with a little white at the same time as you draw in the composition. This ensures that all the shadows show light coming from the same direction.

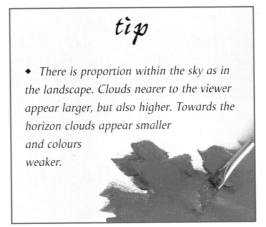

tip

◆ *There is proportion within the sky as in the landscape. Clouds nearer to the viewer appear larger, but also higher. Towards the horizon clouds appear smaller and colours weaker.*

▼ **Towards Dungeness, Kent**
25 x 31 cm (10 x 12 in)
This coastal view was painted during the afternoon looking directly into the light. Clouds were lit from within, so were created using Yellow Ochre and Coeruleum, with a light edge all round them.

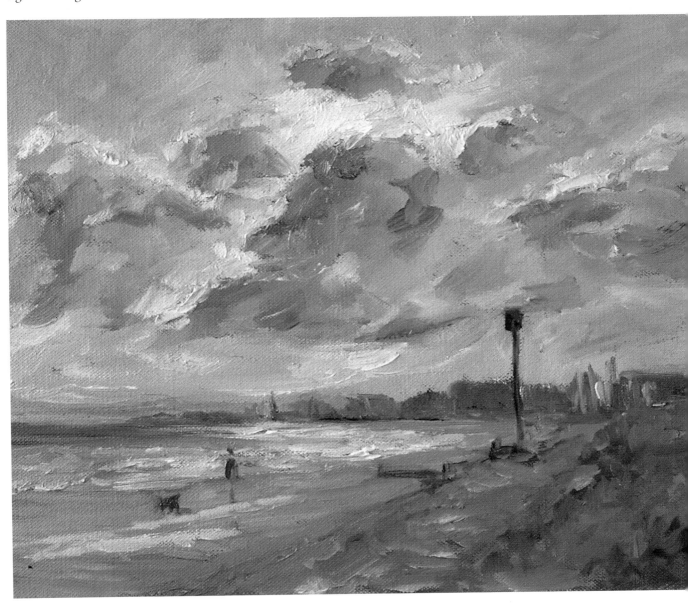

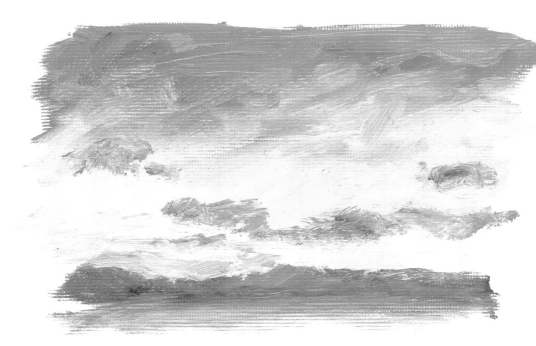

▶ Clear sky

UNDERSTANDING CLOUDS

In order to learn to paint different cloud types, start by copying the examples shown here. Use oil sketching paper and allow 15 minutes for each one. Work to a small scale – no larger, say, than 10 x 15 cm (4 x 6 in) – but use a 16 mm (⅝ in) flat brush. Try not to add too much gel medium and clean your brush only at the end of each exercise. If you find the colours are getting muddy, wipe off any excess paint with a rag or kitchen paper.

Clear sky

Start at the top using a mixture of Coeruleum, French Ultramarine and white. Gradually work towards the horizon, changing the mix to Coeruleum and white only, and then using a little Yellow Ochre and white just above the horizon to create a haze effect. Now add very simple clouds using Alizarin Crimson and French Ultramarine. Finally, indicate distant hills with French Ultramarine, Alizarin Crimson and white to give a sense of scale.

Summer cumulus

Cumulus are the fluffy clouds we see on a summer's day. Start at the top of the paper with the strongest blue tone – again a mix of Coeruleum and French Ultramarine. Place a few patches of blue, then wipe your brush and pick up some white paint tinged with a little Lemon Yellow and Cadmium Orange. Use this to indicate the tops of the clouds. Add

▼ Summer cumulus

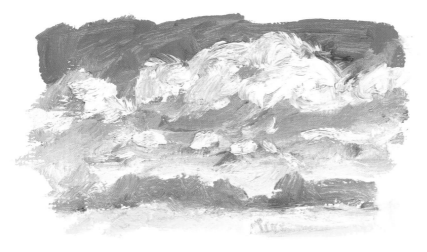

Yellow Ochre and a touch of Coeruleum for the undersides. Beneath the clouds, blue tones in the sky are much softer. Use Coeruleum and white with a little Cadmium Orange to grey the colour.

Mackerel sky with vapour trails

These thin high cloud patterns appear complicated, but are easy to paint. Start as if painting a clear sky using Coeruleum and French Ultramarine, blended downwards and changing the mix to Coeruleum and white only. Then load the brush with white and Yellow Ochre (for a soft cream) and dab on small patches of colour, adding a few dabs of the Coeruleum and white mix in places. A single swift brushstroke creates the vapour trail. Indicate the horizon line with Yellow Ochre and Viridian.

Storm clouds

Using a mixture of French Ultramarine, Cadmium Orange and white, mix a selection of grey tones. Starting with the palest grey, scrub in the overall cloud area, leaving a small section near the top for the light to break through. Paint over this cloud with the other grey tones, keeping your paint fairly 'dry' with very little gel medium, to create shapes within this clouded area. Wipe excess paint from the brush and mix a little Cadmium Orange into white for the patch of sunlight. Having indicated a horizon with Viridian and Raw Sienna, use short downward brushstrokes for sunlight filtering below the cloud. Paint directly into the wet green tone of the horizon, blotting out the horizon here and there.

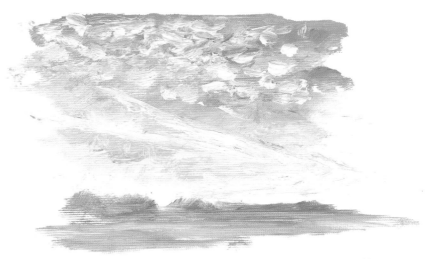

▲ Mackerel sky with vapour trails

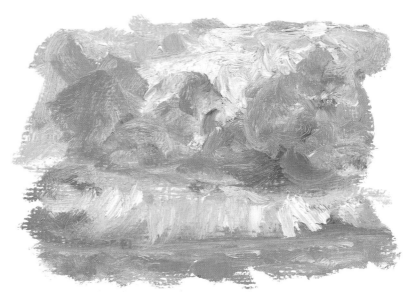

▲ Storm clouds

tip

◆ *Use a 16 mm (⅝ in) flat brush for all of these exercises and apply the paint quickly using fast 'scrubby' marks to give vitality to your work.*

CHANGING LIGHT

Capturing the changing light in the sky from morning to evening can appear rather daunting at first. Not only does the sky vary tremendously with the changing pattern of clouds overhead, but also the overall colour and light in the sky will change during the day, from being predominantly yellow in the morning, more blue towards midday and then with warmish pink/orange undertones in the evening. This is a generalization of the colour changes, and the seasons will add their own subtle variations. In winter particularly skies are often more colourful because the strength of the sun is reduced, while summer skies appear bleached almost white at midday on clear days, offering little inspiration to the outdoor artist.

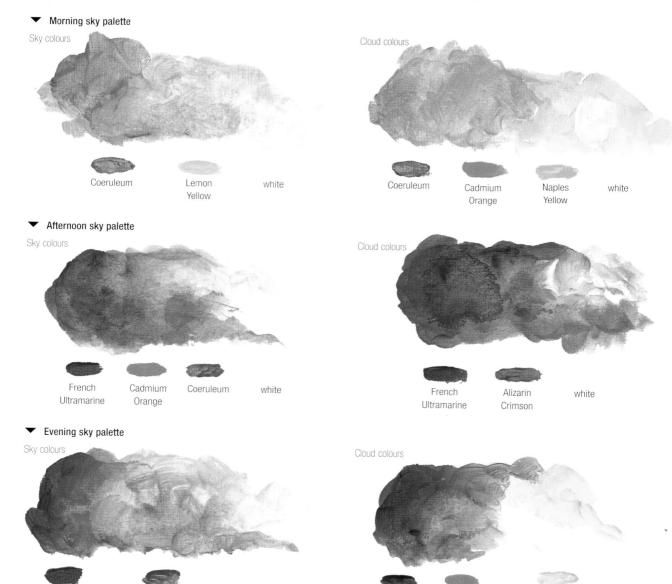

▼ **Morning sky palette**

Sky colours

| Coeruleum | Lemon Yellow | white |

Cloud colours

| Coeruleum | Cadmium Orange | Naples Yellow | white |

▼ **Afternoon sky palette**

Sky colours

| French Ultramarine | Cadmium Orange | Coeruleum | white |

Cloud colours

| French Ultramarine | Alizarin Crimson | white |

▼ **Evening sky palette**

Sky colours

| French Ultramarine | Coeruleum | white |

Cloud colours

| French Ultramarine | Cadmium Orange | Naples Yellow | white |

Morning sky

In the morning skies often carry a yellowish tinge to them, especially towards the horizon. In settled conditions clouds tend to be wispy and strung out. Dawn mists also add to the hazy effect of the morning sky. If you wish to create the effect of mist, use a glaze of French Utramarine and Cadmium Orange applied very thinly over the painting to build up a misty layer along the base of the trees or just above the water on a river scene. This is a very subtle technique and you may need to apply several layers to achieve the desired effect.

The morning palette consists of a blend of turquoise blues and warm yellow tones and might include Coeruleum, French Ultramarine, Cadmium Orange, Yellow Ochre, Naples Yellow and Titanium White.

▼ **Morning Light, Shoreham**
31 x 41 cm (12 x 16 in)
This painting was produced on location on a bright winter's morning. Some clouds have started to bubble up, but are fairly thin and spread out. The rising sun is behind them and its rays shine through onto the cottage roofs. Sunlight tones are a blend of Cadmium Orange, Yellow Ochre and plenty of white to give a very pale gold.

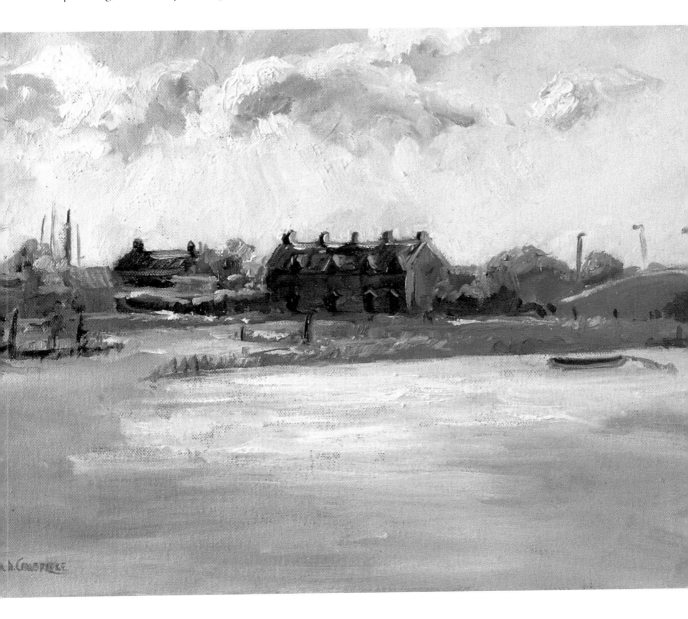

Afternoon sky

Clouds are usually much more in evidence during the afternoon. These summer clouds are easy to paint provided you use the brushstrokes to create a sense of movement, as I have done in *View from Titsey Hill*. In summer the heat of the day will cause cumulus clouds to build up. In winter more turbulent weather conditions bring storm clouds, rain and very dramatic skies. These winter skies can appear very dark indeed, but be careful not to mix your colours too strongly otherwise they will overpower the landscape underneath and may appear rather unrealistic. A mix of French Ultramarine and Alizarin Crimson makes a good basic purple, but this will need to be 'greyed down' using a little Cadmium Orange to take away its intensity. Adding white will enable you to reach the desired shade.

The afternoon palette consists of French Ultramarine, Coeruleum, Alizarin Crimson, Cadmium Orange and Titanium White.

▼ **View from Titsey Hill**
25 x 31 cm (10 x 12 in)
Cumulus clouds were piling up as I painted this view sitting on top of Titsey Hill looking out towards London. The clouds were painted fairly rapidly using a mix of French Ultramarine, Alizarin Crimson and white. Highlights are white and Cadmium Orange, with the surrounding blue mainly Coeruleum.

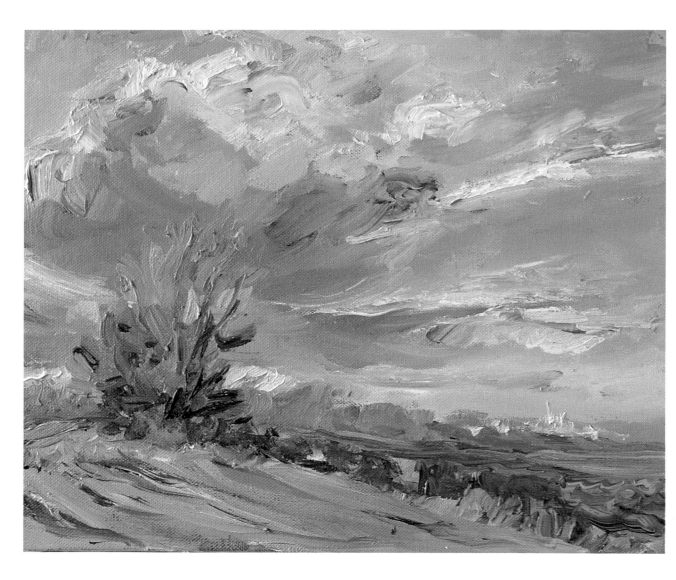

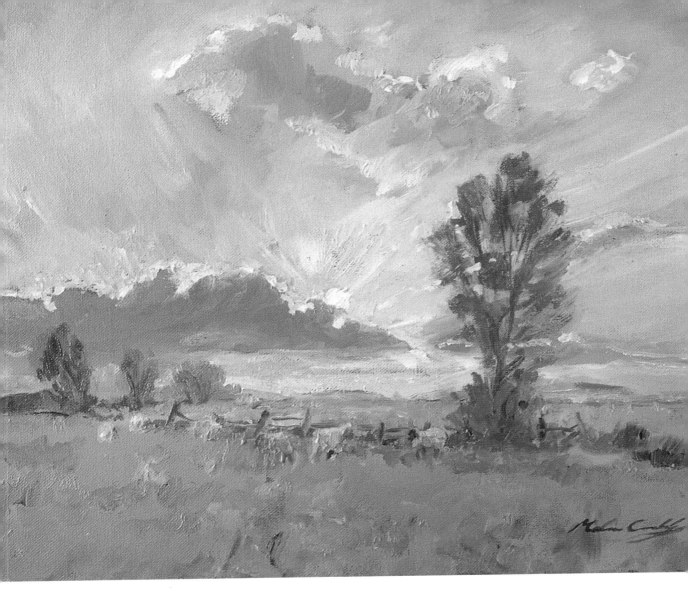

Evening sky

As evening approaches and the sun sinks low towards the horizon, its rays catch the clouds and turn some of them to gold against the darkening turquoise sky. Sunsets are very exciting to paint, with an almost unlimited range of colours. However, it is easy to overdo sunsets by making them too bright and cheerful. Avoid falling into this trap by placing the strongest yellow and orange tones only at the centre of the sunset, the sun itself if this is part of the painting, or the highlights on the clouds caught in the sun's rays. Towards the top of the sky colours are usually much softer and the blues often quite dark. A little Alizarin Crimson added to these blues will darken them and give some purple warmth to the top of the sky. Sunsets vary so much, so simply sitting watching the sun as it sets can be the best way to improve your sunset paintings. It is helpful to make quick sketches in pencil, making lots of colour notes to remind you of each one.

The evening palette includes Coeruleum, French Ultramarine, Cadmium Orange, Raw Sienna, Lemon Yellow, Cadmium Yellow Deep, Alizarin Crimson and Titanium White.

▲ **Sunset over Romney Marsh**
28 x 36 cm (11 x 14 in)
This sunset was painted on location, which meant working extremely quickly. I indicated the main clouds, using Cadmium Orange and Coeruleum for the darker ones, with Raw Sienna and Coeruleum for the upper, sunlit cloud. Sunlit edges were added using Lemon Yellow, Cadmium Orange and white and blended upwards into the sky to create the effect of the sun's rays.

demonstration
Norfolk Sky

The wide, open landscapes of Norfolk are ideal locations for painting skies. Clouds change rapidly, however, particularly on a breezy day, so it is probably easier to work from photographs and sketches. Make plenty of rapid pencil sketches of clouds to develop a sense of movement in the sky and mark in the position of the sun to work out which edges of the clouds will have highlights and shadows.

you will need

canvas 25 x 30 cm (10 x 12 in) (primed with acrylic Burnt Sienna)
brushes: No. 8 short flat, No. 4 short flat, No. 4 round, No. 10 short flat

colours

French Ultramarine, Light Red, Cadmium Orange, Lemon Yellow, Raw Sienna, Coeruleum, Viridian, Sap Green, Alizarin Crimson and Titanium White.

tips

• *Painting a blue horizon helps to create a sense of distance in the picture.*

• *Make the initial shadow area of the cloud a little larger than it will be in the finished painting.*

• *Keep your brush clean by wiping off excess paint rather than using turpentine. This will prevent the brush from becoming too wet. A dryish brush is essential to make the most of the brushmarks.*

• *Paint the highlights on the clouds much thicker than the shadow side. This makes them look much more effective.*

• *Try to finish the sky in about half an hour. Working quickly keeps the brushstrokes lively and holds your concentration too.*

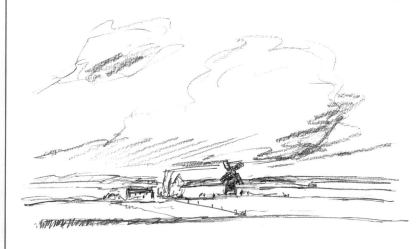

▲ **STEP ONE**
My initial sketch concentrated on the overall shape of the main cloud and was drawn rapidly with sweeping lines to give an impression of movement. The horizon is low down in the composition to leave plenty of space for the clouds. The buildings and windmill act as a focal point.

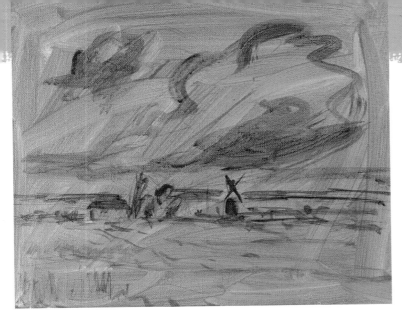

◀ STEP TWO

I primed the canvas with a wash of Burnt Sienna, using acrylic rather than oil paint as it dries quickly and allowed me to start painting almost straightaway. Painting on a warm undertone is particularly helpful for sky subjects. Using a No. 4 flat brush and French Ultramarine, I marked in the horizon, foreground buildings and the two main cloud shapes, including their shadow sides.

▶ STEP THREE

The horizon line was painted using French Ultramarine and white, with a little Viridian and Raw Sienna added to the mix as I painted down towards the line of buildings. The left-hand building was painted with Raw Sienna and French Ultramarine, and I used Light Red and French Ultramarine to establish the darker shape of the windmill. Both these shapes were painted with a No. 4 round brush. The trees alongside are Sap Green and Raw Sienna.

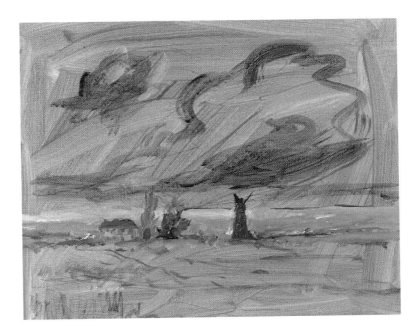

◀ STEP FOUR

With the horizon and middle ground established, I could turn my attention to the sky. The whole sky is painted with No. 10 flat brush. This might seem too large a brush for such a small canvas, but the key to painting large clouds successfully is to use the individual brushmarks to create an impression of movement. I started at the top of the canvas with a mix of French Ultramarine and Coeruleum, and just a little white, and painted the blue sky down to the top edge of the clouds.

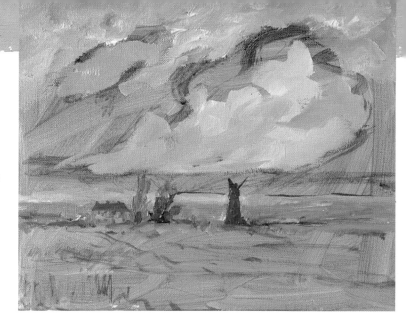

▶ **STEP FIVE**

I mixed Alizarin Crimson, French Ultramarine and white for a soft grey tone and blocked in the cloud from its bottom edge. This would form the shadow base to the clouds and give some colour to blend into when the top half of the cloud is added.

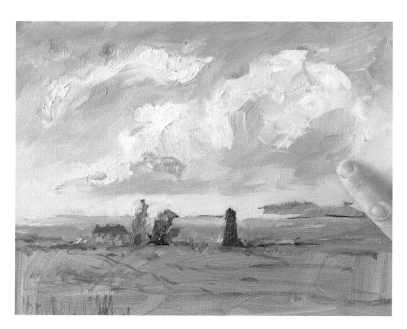

◀ **STEP SIX**

After wiping off the paint from my brush, I loaded it with colour for the top of the cloud (using mainly white with a little Cadmium Orange to start). I applied the paint thickly and with definite brushstrokes, working in different directions to create cloud shapes. Then I blended this lighter colour over some of the shadow tone, adding a very little Raw Sienna to the centre of the cloud. I painted around the clouds using Coeruleum and white, making the colour paler and adding a little Cadmium Orange where the sky meets the horizon. I blended the bottom edge of the cloud with a finger for a softer effect.

▶ **STEP SEVEN**

With the sky completed, I used a No. 8 flat brush to scrub in the foreground with Sap Green and Raw Sienna. Darker areas were produced by adding Cadmium Orange to the Sap Green and the hedgerow was also marked in using this mix.

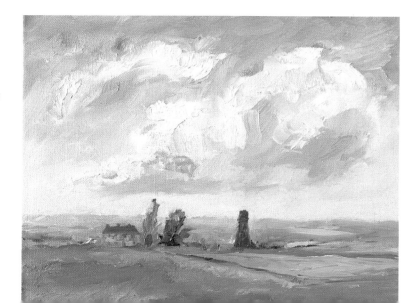

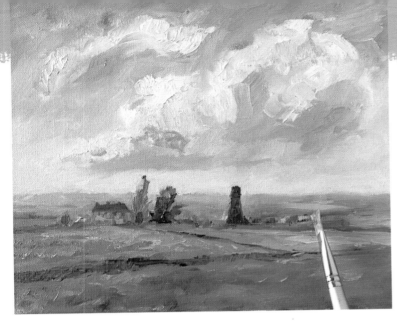

◄ STEP EIGHT

I painted more detail and used the Sap Green and Cadmium Orange mix as a dark tone for extra bushes and a ditch right across the foreground. Extra texture was given to this area with Lemon Yellow and Cadmium Orange. Finally (*see below*), I used a No. 4 round brush to paint sails on the windmill and to add a row of fence posts along the central hedgerow.

▼ **Norfolk Sky** 25 x 30 cm (10 x 12 in)

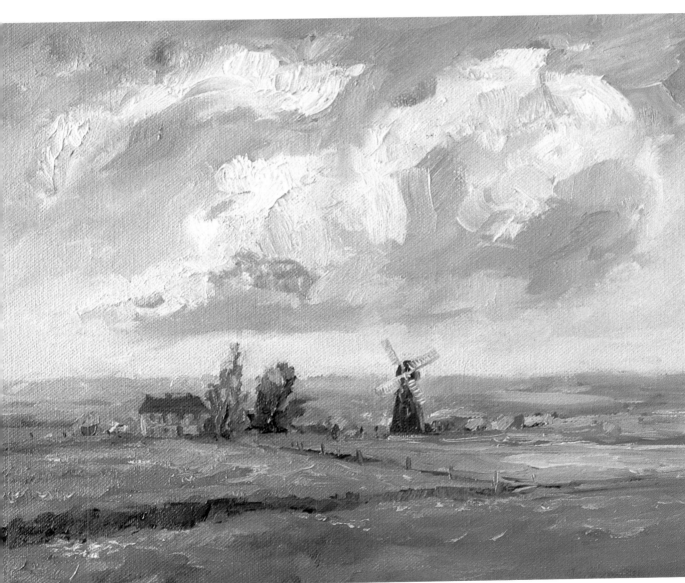

Trees for all Seasons

Trees are an integral part of the landscape. Not only do they grow in all shapes and sizes, but the colours vary enormously, starting with the full range of green shades in spring and summer, then changing to wonderful golds, reds and oranges in the autumn. Even in winter the bare branches of some varieties appear red, soft orange or even purple in the clear sunlight.

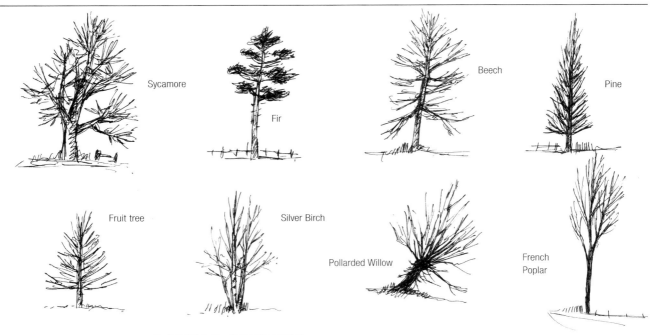

Sycamore

Fir

Beech

Pine

Fruit tree

Silver Birch

Pollarded Willow

French Poplar

LOOKING AT TREES

In order to paint realistic trees it is helpful first of all to learn a little about the structure of different varieties. This is easiest in winter when most trees are devoid of leaves. Start off by sketching the shapes of trees around you, in the garden or the local park. Make only small sketches and concentrate on getting the overall shape right, rather than capturing each and every branch. Remember, too, that even a simple

▶ **Clear Light, Romney Marsh**
25 x 31 cm (10 x 12 in)
This painting is a good example of how a single tree can provide the main point of interest in a composition.

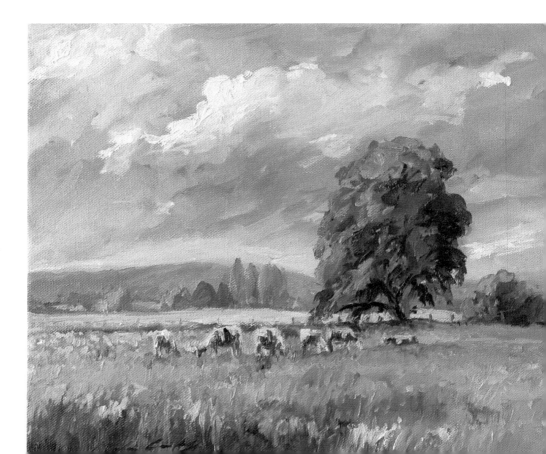

painted sketch of a tree needs to show its light and shadow sides. Use the tree sketches you have made to produce a series of small painted versions. To simplify the difference between the light and shadow sides, mix only two shades of green to begin – Viridian and Light Red for the dark tone, Viridian and Raw Sienna for the lighter green. Block in the dark areas first of all – do not worry about the branches, just block in the basic shape. While the paint is still wet add the lighter areas on top, blending together if you wish.

Distant trees and hedges

This basic light over dark technique is also ideal for depicting distant banks of trees and hedges and, indeed, I make great use of this method in my paintings. Again, start off with your dark tone, blocking in the basic hedge shape, then add highlights on top to create the finished hedge. Obviously this technique is only suited to far distant trees where details of branches and sky holes are not visible, but it is a simple way to start.

Another method for portraying distant trees, particularly in misty conditions, is to paint the shapes almost in silhouette. To do this I mix up a warm grey tone and block in the top edge of the trees with a flat brush. Then I use the edge of the same brush to indicate a few main branches. Towards the base of the trees I block in more flat shapes to add the impression of trunks. While working it is important to alter the grey tone slightly, making it a little darker for the trees closest to the viewer.

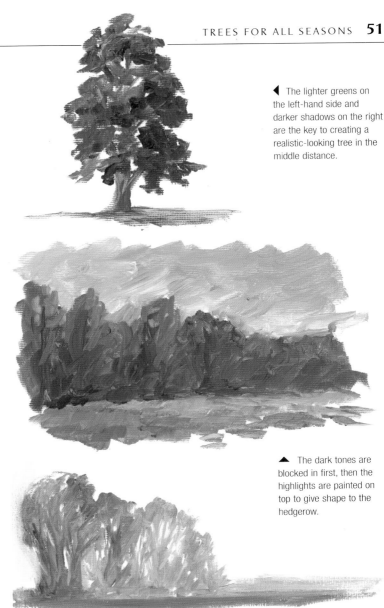

◀ The lighter greens on the left-hand side and darker shadows on the right are the key to creating a realistic-looking tree in the middle distance.

▲ The dark tones are blocked in first, then the highlights are painted on top to give shape to the hedgerow.

▲ Trees in the far distance have very little noticeable detail other than a suggestion of the main trunks and branches.

tips

◆ *Keep the initial dark tones fairly thin and add much thicker, stickier paint on top for the highlights.*

◆ *Unless a tree is in the foreground, keep details to a minimum. Individual leaves cannot easily be seen from 100 metres away.*

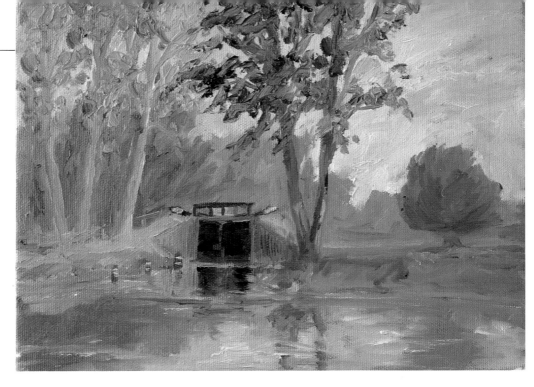

▶ **Below Newark Lock**
20 x 25 cm (8 x 10 in)
In this painting of Newark Lock
you can see trees painted in all
three distance planes, from the
bank of trees in the far
distance, with very little detail,
through to the foreground
trees where individual
branches and sky holes are
clearly visible.

▼ **Below Newark Lock**
(detail)
The sky holes have been
added last, applying the
paint very thickly in single
brushstrokes.

Foreground trees

As you look more closely at individual
trees you will see much more detail,
including smaller branches and
individual leaves, although even when
painting trees in the foreground, it is not
necessary to paint every leaf. Instead, try
establishing the main areas of colour,
light and shade within the overall tree
and then look at sky 'holes', the shapes of
individual branches and clumps of
foliage. Working in this way you will
show a considerable amount of detail
and yet avoid 'painting every leaf', so
keeping your overall painting looking
impressionistic, rather than
photographic, in style.

SKY 'HOLES' AND OTHER DETAILS

When working in oils it is usually easier
to paint the sky last. However, where
there is a tree in the foreground of a
painting, this can present a problem.
What if you have painted the tree first
and it is too solid? You will want to add
some 'holes' in the foliage for the sky.

Before doing so, scrape off any excess
paint with a palette knife, though it will
not be possible to remove every trace of
green. When adding sky colour, load the
brush with plenty of paint and place it
carefully, using a single brushstroke to
create each hole. This will enable you to
paint clean patches of light colour over
an area that is still wet and previously
covered with darker tones. If you try to
blend the paint it will pick up any
underlying colour and your sky will turn
muddy. If this does happen, scrape off
your mistake with the palette knife and
try again – oils are very forgiving and
will enable you to do this several times.
As well as applying the sky colour very
thickly, wipe off your brush after every
stroke to keep the colour clean.

TRUNKS AND BRANCHES

Choosing the correct colour for tree
trunks and branches also needs care.

Some trees, such as the silver birch, have a very specific coloured bark, but the colour of all tree trunks and branches is affected by the light. Sometimes, when the sun is fairly low, tree trunks can stand out as very pale colours against their dark foliage. When seen against the light (that is, with light coming from behind them), most trunks and branches appear almost black. The only time branches appear to be their actual colour is in flat, dull conditions.

COPING WITH SHADOWS

I am often asked by students, 'what colour is a shadow?'. This, of course, depends upon the colour of the object that is casting the shadow, but I have found that in landscape painting the shadow invariably contains a large amount of blue. When painting shadows cast by trees I indicate all the shadows using French Ultramarine on the wet underpainting, unless I am working directly onto dry canvas. The wet paint blends easily and also picks up some of the underlying colours. Usually, I find that simply painting the shadows directly in blue is enough.

As well as shadows cast by trees, in particularly sunny conditions the leaves of the tree may cast delicate shadows on the trunk itself – perhaps most noticeable on pollarded trees. These shadows need to be painted very softly; a darker tone of the tree trunk's own colour usually works well. Otherwise, a soft grey tone mixed from Coeruleum and Cadmium Orange can also be used to successful effect.

tip

- *Paint the branches of the trees in the direction of growth.*

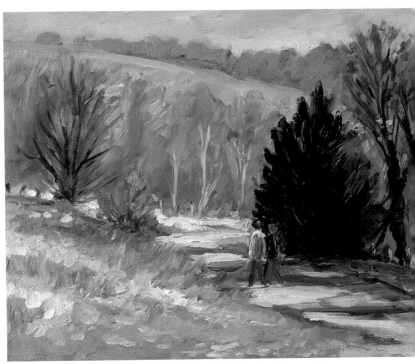

▼ **First Snow, Riddlesdown**
25 x 31 cm (10 x 12 in)
The shadows on the lane were painted using pure French Ultramarine, enabling the blue to pick up some of the underlying tones and creating wonderful clean shadows.

◀ The shadows on the top of the trunk of the tree have been painted using a soft grey tone mixed from Cadmium Orange, Coeruleum and white.

THE CHANGING SEASONS

The colours of trees change with the seasons and, being such an integral part of the landscape, they have considerable impact on the finished painting.

Spring

In spring the new leaves bring fresh vibrant greens and yellows. These acidic green and yellow tones are exciting colours to paint. For the most impact save the strongest tones for the foreground trees, toning down the colours in the middle ground by adding more Coeruleum to the green shades and a little white to make them paler. The presence of wild flowers such as cow parsley and buttercups in a hedgerow in England also helps to create the impression of a spring scene – just a few white or yellow stippled marks are often all that is needed.

Key colours for spring greens are Lemon Yellow, Cadmium Orange, Coeruleum, Viridian and Raw Sienna. Mix Lemon Yellow and Coeruleum to make a strong bright green that is the basis for spring greens. Adding extra Lemon Yellow gives a bright acid tone, while Cadmium Orange produces a warmer green. Try using Viridian as a base for dark greens, adding either Cadmium Orange or Raw Sienna to soften this very strong colour.

▼ **Newark Lock**
25 x 31 cm (10 x 12 in)
The brightest spring greens have been reserved for the foreground trees. The contrast against the darker central tree adds extra interest to the picture.

Summer

In spring woodlands offer a riot of bright greens and yellows for the oil painter, but in summer I prefer to concentrate on other landscape features such as fields and flower meadows, using trees as a setting rather than the main subject. This is because as spring moves into summer greens tend to become somewhat duller and darker, forming a gentle background to the stronger golden yellows of corn and other crops as they ripen. High summer can be a difficult time to paint trees as their green tones often seem dull and uninteresting, lacking the wide variety of colour that is seen in either spring or autumn.

The summer palette is dominated by darker greens and warm red tones: Raw Sienna, Viridian, Alizarin Crimson, Cadmium Orange, Light Red and French Ultramarine. Use Viridian as the base green, and add Alizarin Crimson for a very dark tone. Alternatively, a little Light Red mixed with Viridian makes a warmer, yet still dark, green. Cadmium Orange or Raw Sienna with Viridian both make good mid-tone greens.

▲ **Cornsilk**
30 x 41 cm (12 x 16 in)
As spring moves into summer trees lose their initial brightness, becoming softer and bluer in tone, forming a lovely backdrop to the strong yellows and golden shades of ripening crops and haystacks.

▲ **Autumn Colours, Wisley**
25 x 31 cm (10 x 12 in)
Despite the use of many strong autumn colours, tones in the middle ground have been softened using a little blue and white to keep a sense of depth within this woodland scene.

Autumn

As autumn arrives the greens turn gold, bright yellow or rusty orange, offering a wonderful range of colours for the artist. Beware, however, of making these colours too strong in your paintings as they can appear a little false. Remember that the effect of the intervening atmosphere will soften the look of all colours, even for trees that are only a few metres away from you.

Key colours veer towards a stronger, brighter range: Lemon Yellow, Cadmium Orange, Light Red, Yellow Ochre and Viridian. Warm orange tones tend to dominate autumn trees, so try a mix of Cadmium Orange and Lemon Yellow for the brightest tones. Yellow Ochre and Light Red make superb darker orange shades. Once again try Viridian with a little Cadmium Orange or Light Red for the darker shadow side of autumn trees.

Winter

Winter brings its own reward for the artist, especially on a clear cold morning, when the range of colours is far wider than the expected subdued grey tones. Distant trees can take on a purplish hue, with many warm orange tones visible. A number of trees and shrubs have strongly coloured branches, not normally seen when they are covered in leaves, but in winter these shrubs are seen in their full glory, adding rich colours to the landscape. A snowfall also obviously has its own magic, highlighting some colours, especially in bright sunlight, and creating deep blue shadows as well.

These strong tones bring warm colours to the basic tree palette: Alizarin Crimson, Cadmium Orange and Light Red, as well as cooler Coeruleum and French Ultramarine. Use Alizarin Crimson and French Ultramarine for the darkest purple shades. Light Red and French Ultramarine give a warm black for tree trunks and some branches. Use Cadmium Orange and Coeruleum with white to mix a whole range of warm and cool gréys (see page 24).

▼ **Winter Snow, North Downs**
31 x 41 cm (12 x 16 in)
Snow is seldom pure white, even on sunny days. Note how dark the foreground snow appears when compared to the white of the surrounding page.

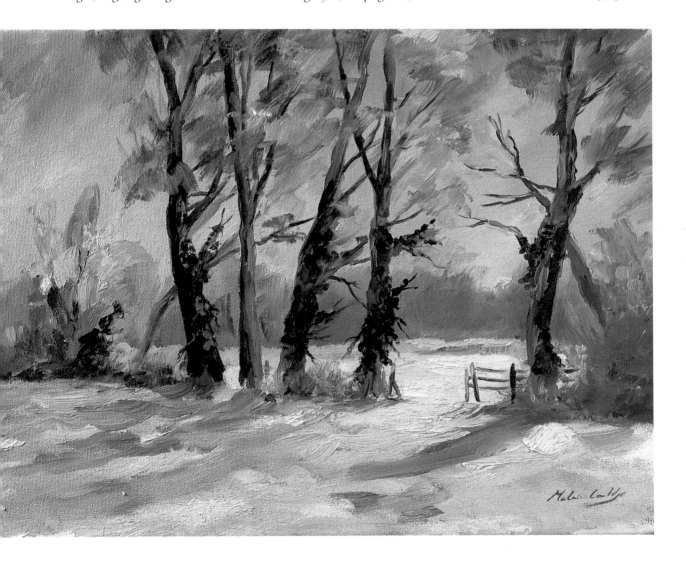

demonstration
Summer Haystacks

Late summer is a wonderful time for painting. The fields turn to gold as wheat and barley ripens and there is often a blue haze to distant hillsides. In my painting I have tried to concentrate on the colour and simplicity of the scene, treating the haystacks as simple blocks and looking at the trees and background hedgerow as areas of different colour rather than painting the individual leaves.

you will need

canvas 30 x 40 cm (12 x 16 in) (primed with acrylic Burnt Sienna)
brushes: No. 10 short flat, No. 8 short flat, No. 4 rigger

colours

Titanium White, Lemon Yellow, Cadmium Yellow Deep, Raw Sienna, Light Red, Alizarin Crimson, Coeruleum and French Ultramarine.

tips

◆ *Work directly over the wet paint using lively, short brushstrokes to give a sense of movement.*

◆ *Do not clean your brush while painting the stubble field; the mix of colours will help create a textured effect. Small patches of Raw Sienna also help to give a feeling of depth towards the foreground.*

◆ *Do not clean your brush until the whole sky is finished. If necessary, wipe off any excess blue paint with a clean rag.*

◆ *When painting the sky holes, apply a large amount of paint in one brushstroke to prevent the underlying colour showing through.*

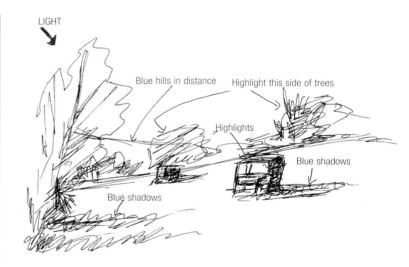

LIGHT

Blue hills in distance

Highlight this side of trees

Highlights

Blue shadows

Blue shadows

▲ **STEP ONE**

Wherever possible, I try to work from a sketch made on location rather than a photograph. My sketch for *Summer Haystacks* is covered with colour notes and arrows indicating areas of light and shade. Particularly note the large arrow in the top left-hand corner, indicating the direction of sunlight on the scene.

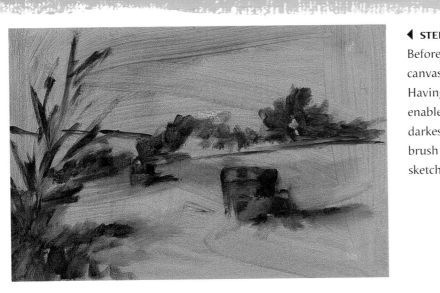

◀ STEP TWO

Before starting the painting I primed the canvas with a wash of acrylic Burnt Sienna. Having a coloured ground to work on enables you to see both the lightest and darkest tones straightaway. With a No. 8 flat brush loaded with French Ultramarine, I sketched in the key areas of the painting.

▶ STEP THREE

I used French Ultramarine and white to paint the distant hillside. Then I mixed Lemon Yellow and Coeruleum for a bright green and I added French Ultramarine for a darker shade. With the dark green, I painted a line of lively brushmarks for the shadows along the hedgerow, then finished with the lighter green. I started to paint the field using a No. 10 flat brush with mixes of yellows. The left-hand tree was blocked in using Raw Sienna and Cadmium Yellow for the sunlit side, with Light Red added for the shadow.

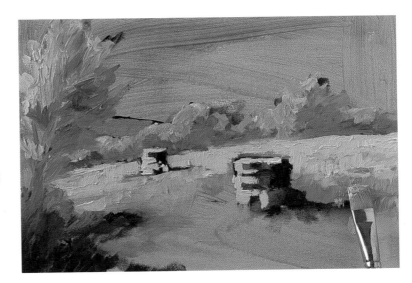

◀ STEP FOUR

I continued painting the stubble field with a No. 10 flat brush, holding the brush upright and using short downward brushstrokes to create the stubble texture. Then I turned to the sky, starting at the top of the canvas with the strongest blue mixed from Coeruleum and white. Using fast, scrubby, brushstrokes, I blocked in the top of the sky, adding more white with a little Cadmium Yellow for the tops of the clouds. Shadows on the clouds were mixed from Alizarin Crimson, Coeruleum and white.

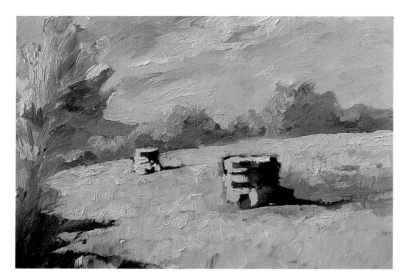

◀ **STEP FIVE**

I finished painting the whole sky area using the same approach and taking care to ensure that the colour graduated from light blue at the top, through warm yellow in the middle to a pinkish yellow at the horizon.

▶ **STEP SIX**

With the whole canvas now covered in paint, it was time to put in the details and bring the painting to life. Using a No. 8 flat brush, I painted the haystacks. These are simple cube shapes, created using short vertical and horizontal brushstrokes. I used Cadmium Yellow and Raw Sienna, but added French Ultramarine for the shadow side of the haystacks and the shadows thrown by the left-hand tree.

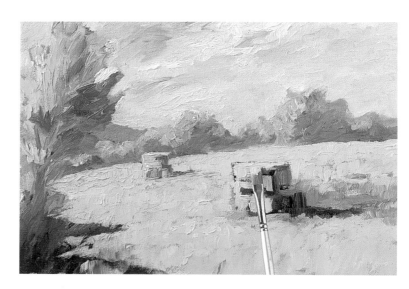

◀ **STEP SEVEN**

The yellow stubble field appeared rather too bright in the foreground, so I softened this with a little Coeruleum applied directly over the yellow with a No. 10 flat brush. I used only light pressure on the brush to avoid picking up too much underlying yellow. Shadows from the haystacks and the left-hand tree were strengthened using French Ultramarine and Light Red.

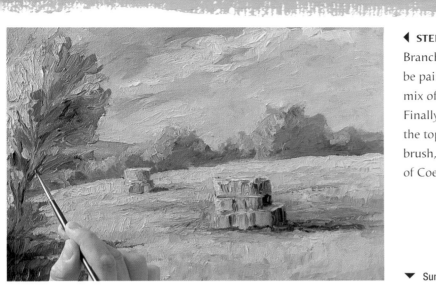

◀ STEP EIGHT

Branches in the foreground tree could now be painted using a No. 4 rigger brush with a mix of French Ultramarine and Light Red. Finally (*see below*), I painted sky holes into the top quarter of the tree using a No. 8 flat brush, heavily loaded with the sky tone mix of Coeruleum and white.

▼ **Summer Haystacks** 30 x 40 cm (12 x 16 in)

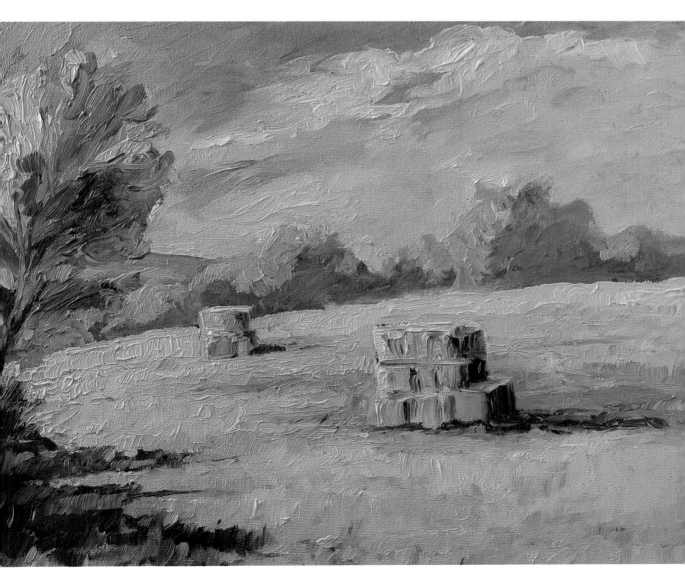

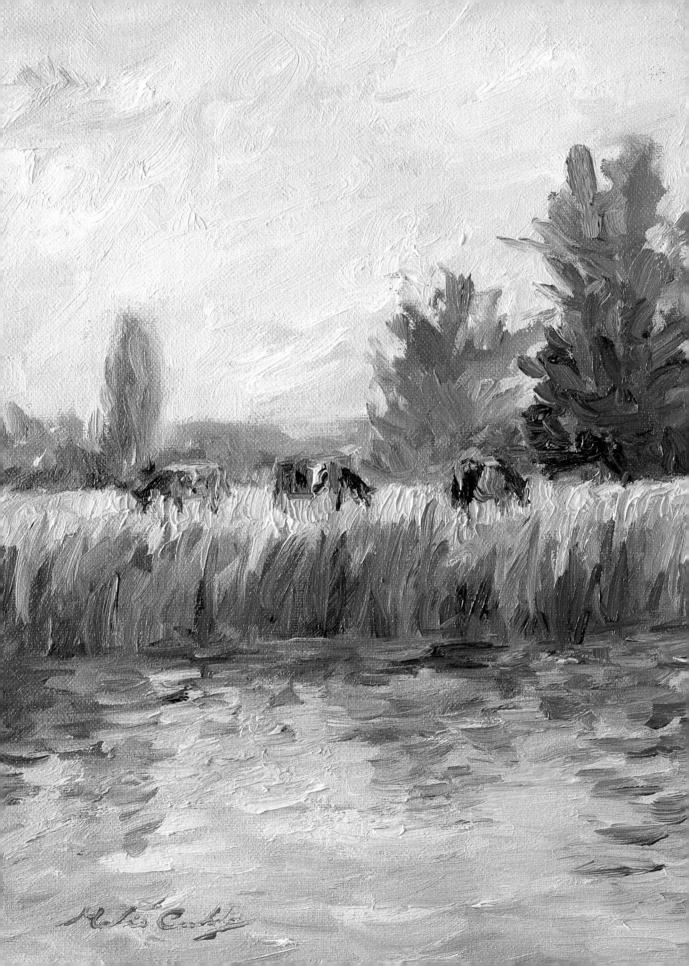

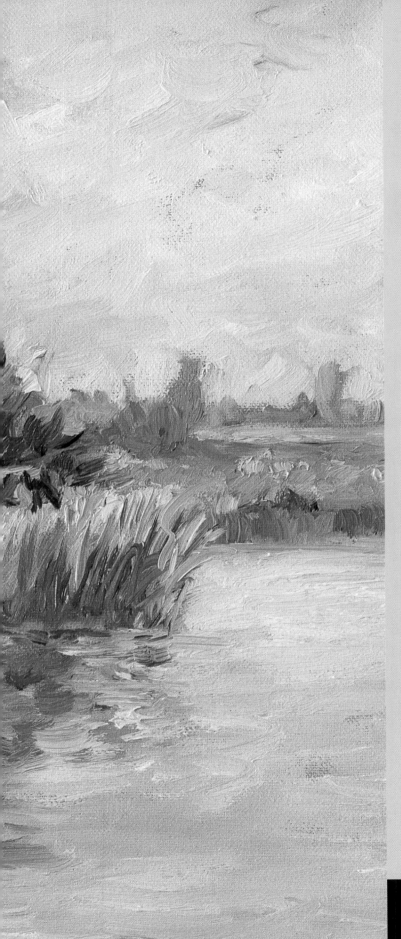

Water and Reflections

Having the confidence to paint water opens up a range of popular subjects for the artist – quiet rivers, lakes and even the open sea, not to mention waves crashing onto the beach. By keeping to a few simple rules and following the practical examples in this chapter you should start to gain confidence when you are faced with a water scene, whether moving or still.

◀ **Sunrise, River Wey**
31 x 41 cm (12 x 16 in)

STILL WATER

Painting water with oils should be very straightforward. The fact that oil paint can be worked directly on top of wet underpainting is a definite advantage when painting water. Colours slightly blend together automatically, without any real effort from the artist.

Reflections

Reflections in calm water are probably the easiest way to start painting water. Even so, there are a few points to bear in mind. Reflected colours tend to become slightly duller with less detail. This is because of the degree of clarity of the water itself; for example, in a still pond the water may be full of algae or sediment and this will affect the reflected colours. Even the slightest breeze over water causes tiny ripples that will distort the reflection.

▼ Reflections in a moving surface appear rather distorted. However, unless the water is very rough, the reflection of the mast of a boat is still at least as tall as the actual mast.

▶ Where a post leans at an angle its reflection is at the opposite angle.

Another key point to be aware of is the size of the reflection. For instance, when painting the mast of a moored yacht, the reflection is often longer than the actual mast, particularly in very calm water. Remember also to take into account the angle of the reflection.

Adding ripples

Before considering more complicated scenarios, try painting a simple still water reflection with just a few ripples breaking the surface. Keep the pressure

tips

◆ Remember to add just a little of the complementary colour, red, to dull down the green tones for the reflections.

◆ Use shorter brushmarks fairly close together for ripples in the foreground. Several longer lines will be sufficient for the middle and background.

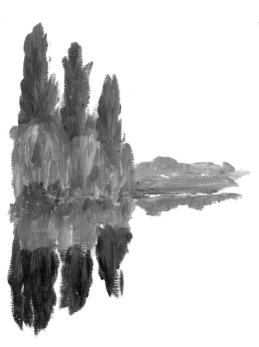

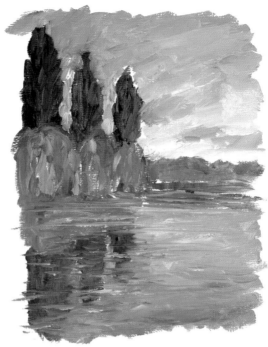

◀ Start by painting the reflection, using downward brushstrokes only. Concentrate on getting each colour in the right place and approximately the right shape. Patches of sky also appear slightly darker in tone, so these areas should be blended towards the bottom of the reflection, ensuring that the whole area of water is covered with softly blended oil paint. Add the surface ripples in a series of short horizontal brushmarks with a No. 4 round brush.

▼ **Fishing Hut on the Charente**
51 x 41 cm (20 x 16 in)

of your brush fairly light so as to avoid the brush picking up too much underlying colour. If you find that you are mixing 'mud' try painting the ripples with a lot more paint to give almost an impasto effect. Clean your brush after each brushstroke, so removing any undercolour picked up and keeping the highlights and ripples clean.

Working wet-into-wet

One great advantage of painting water with oils is the ability to work wet-into-wet, even on consecutive days, thus allowing plenty of time to get the reflection right before moving on to add the surface ripples. Painting the ripples directly onto the wet reflection means that some of the underlying colour will be picked up by the brush and the ripples will blend themselves slightly into this wet surface, so becoming a part of the water rather than just sitting on top of the painting.

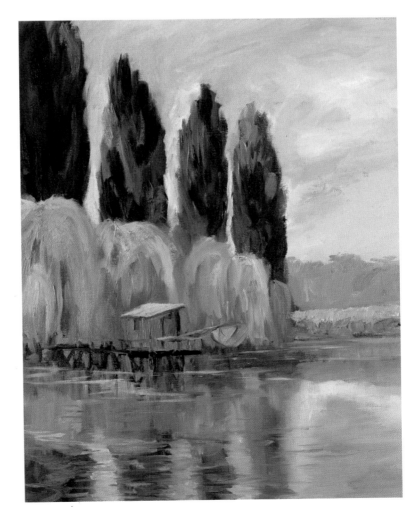

MOVING WATER

When painting rivers and lakes, the technique is fairly similar. However, when painting at the coast, capturing the colours and movement of the sea require a somewhat different approach. To start with, the sea is seldom calm enough to cause mirror-like reflections. Its colour is probably most influenced by the sky above, while the amount of movement, the size of the waves etc. is governed by the effect of the prevailing winds.

In deep water the sea tends to reflect the darker blues from the sky, often appearing very dark blue towards the horizon. Use French Ultramarine with a little Cadmium Orange, but no white, for this wonderful dark sea blue. Similarly, bands of dark green are sometimes seen in this part of the sea where clouds cast shadows on the surface. Use a combination of French Ultramarine and Viridian for the darkest greens, adding a little Raw Sienna to make them lighter if required. Moving forward towards the beach, the sea is much shallower and its colour is affected by the beach, appearing first as a paler green, which can be mixed from Coeruleum and Yellow Ochre. It becomes almost yellow

▼ **The Blue Yacht, Porchester**
28 x 36 cm (11 x 14 in)
In this view across Portsmouth Harbour the distant water was quite choppy. I used short horizontal brushmarks for the waves and painted flatter areas of colour in the foreground where the water was calmer.

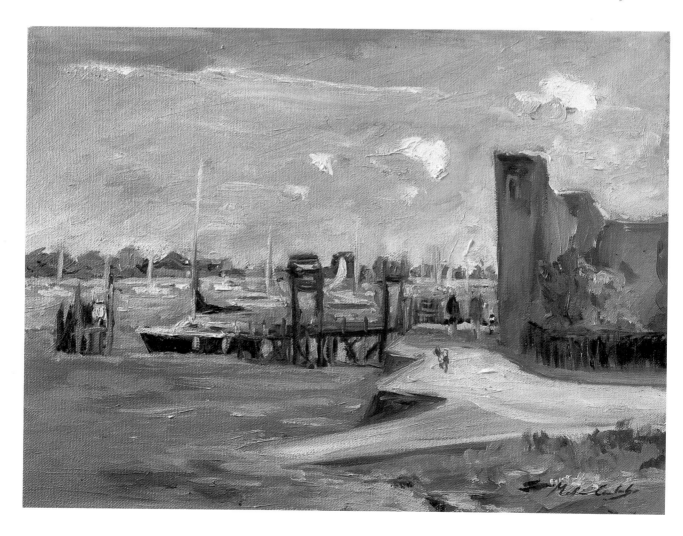

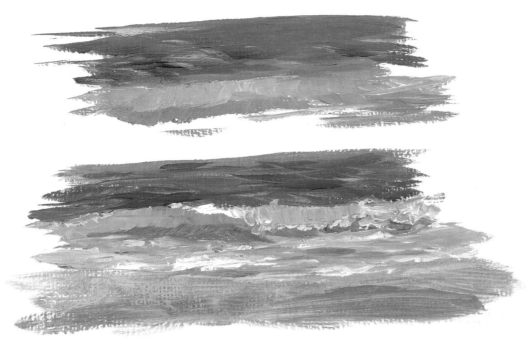

◀ Sweep a mix of blues across the paper for the sea on the horizon. Moving down, paint a greenish stripe under the dark blue, finishing off with a very yellowish band to form the back of the breaking wave.

◀ Add the foam breaker, using white with a little Raw Sienna. A few vertical brushmarks give the effect of falling water, with dabs of cream for the breaking surf. Check that the shadow under the foam is dark enough. Add squiggles to represent foam patterns on the shallow water that is creeping up the beach. Finally, indicate the beach with a little Raw Sienna.

where the waves break and pick up sand deposits, so more Yellow Ochre or a little Lemon Yellow should be added to the prevous mix for this final shade. These sea colours are obviously just a guide, but use them for a sound starting point.

Simplifying waves

While some artists devote all of their efforts to painting the open sea, most only paint the sea as part of a beach scene. Waves break onto the shore in a fairly standard way, so by learning how to paint one wave you will have the key to success!

Beach reflections

Unlike reflections in still water, reflections on a beach are usually only found in the wet sand and even here they are quite distorted, needing a somewhat different approach. Rather than paint the reflections first using downward brushstrokes, incorporate

them into the painting of the beach itself using mainly horizontal brushstrokes.

The key to a successful beach reflection is not to try to be accurate. For example, the reflection of a figure with a white T-shirt and green shorts would simply be a long squiggle of skin tone followed by a small green squiggle and a slightly larger white squiggle. Finally, add another small skin tone mark.

▼ **Surf's Up, Polzeath Bay**
51 x 61 cm (20 x 24 in)
There were plenty of breakers at Polzeath Bay in December. I included several lengths of surf to give the impression of a rough incoming sea breaking onto the beach.

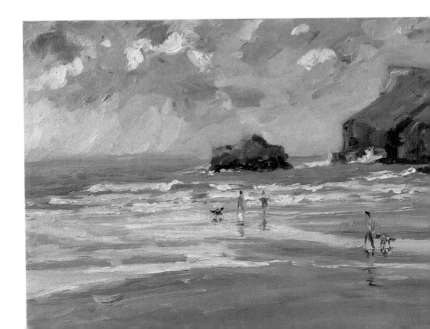

demonstration
The Thames at Bourne End

This tranquil view of the River Thames near Bourne End, with the sailing dinghies drifting along, made an irresistible subject. The water was calm enough to see the long reflections from the sails of the dinghies, yet parts of the surface were covered in ripples from the flow of the river. I particularly liked the contrast of white sails against the dark trees and wanted to make this the key element in my finished painting.

you will need

canvas 30 x 45 cm (12 x 18 in) (primed with acrylic Burnt Sienna)
brushes: No. 8 short flat, No. 4 round, No. 4 rigger, No. 10 short flat

colours

French Ultramarine, Cadmium Orange, Raw Sienna, Viridian, Coeruleum, Alizarin Crimson and Titanium White.

tips

◆ *Let the brushmarks create the impression of trees by working in different directions to give a three-dimensional effect.*

◆ *Paint the reflections using downward brushstrokes only, blending to give a smooth surface.*

◆ *Reflected sky tones should be just a little darker than the actual sky.*

◆ *Use very light pressure on the brush when adding reflections and wipe the brush after each stroke over the canvas to prevent it picking up too much underlying colour.*

◆ *Balance the composition by painting the foreground reflections of the trees and dinghies off the bottom edge of the canvas.*

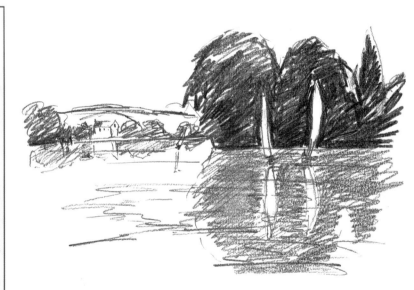

▲ **STEP ONE**
My initial drawing of the scene concentrated on the overall composition and position of the two dinghies in the foreground. The reflections of the dinghies have also been drawn in – note how they are slightly longer than the height of the actual sails.

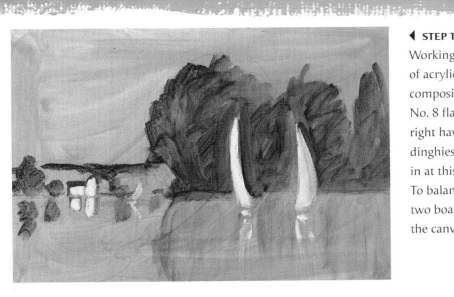

◀ **STEP TWO**

Working on a canvas tinted with a thin wash of acrylic Burnt Sienna, I blocked in the main composition using French Ultramarine and a No. 8 flat brush. Note how the trees on the right have been painted as solid shapes. The dinghies and distant house were also blocked in at this initial stage, using pure white paint. To balance the composition, reflections of the two boats go off the edge of the bottom of the canvas.

▶ **STEP THREE**

I started to paint the far hillside using a No. 8 flat brush loaded with Viridian, French Ultramarine and white. In front of the hillside is a bank of trees running down to the water's edge and I used the same mix of colours, but with less white and a little Raw Sienna, for these. With the same colour on the brush, I marked in the reflections of these trees. This was done by holding the brush flat to the canvas and dragging down at least as far as the height of the trees.

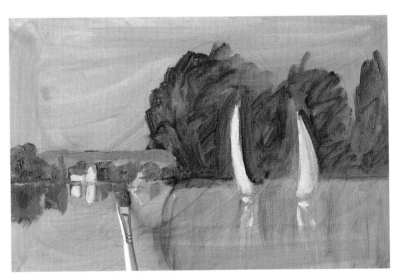

◀ **STEP FOUR**

Using a No. 10 flat brush, I strengthened the initial shapes of the foreground trees on the right-hand side with a mix of Viridian and a little French Ultramarine first, then with Raw Sienna added for the lighter tones, and Cadmium Orange for the darks. I concentrated on the overall shape of each tree. At the same time, and using downward strokes, I painted the reflections of the trees to the bottom of the canvas. A little space was left for the sky tones to reflect between the two poplar trees on the far right.

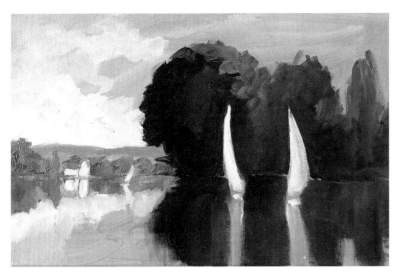

◀ STEP FIVE

Now I could paint the sky and its reflection. Using the No. 10 flat brush, I started at the top with the darkest blue tone mixed from Coeruleum and white with a little French Ultramarine. Keeping the brushstrokes fairly fluid, I painted down towards the horizon, adding white to lighten the colour and finally adding a little Cadmium Orange near to the horizon. While working on the sky I added sky tone to the water reflections, using the same brush, but applying the paint evenly with blended downward-only brushstrokes.

▶ STEP SIX

I continued painting the sky and its reflection until all the canvas was covered with paint. The water reflections were now finished and only the ripples remained to be added. Before doing this, however, the foreground trees needed to be brought to life. I added sky holes to the top of these trees, using plenty of sky colour and wiping the brush after each brushstroke. Next I used a No. 4 rigger to paint the tree trunks and branches with Raw Sienna. Finally, texture was added to the trees using Viridian and Raw Sienna.

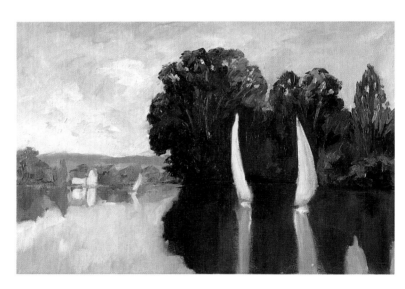

◀ STEP SEVEN

Painting the surface ripples is an easy and enjoyable process. I started with a No. 4 round brush loaded with a pale grey tone mixed from Coeruleum, Cadmium Orange and white. Holding the brush at a gentle angle, I drew in just a few horizontal lines over the reflection of the distant hillside. It is best to work slowly at this stage and to try to keep these lines as horizontal as possible, using a mahlstick if you prefer.

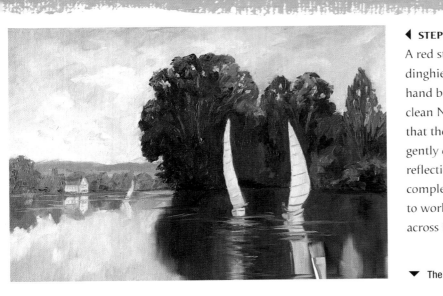

◀ **STEP EIGHT**

A red stripe was added to the hulls of the two dinghies and a figure painted into the right-hand boat. For the foreground ripples I used a clean No. 10 flat brush. I held it vertically so that the edge just touched the wet paint and gently dragged it from the white sail reflections into the dark tree reflections. To complete the painting (*see below*) I continued to work slowly, blending the pale reflections across into the darker areas.

▼ **The Thames at Bourne End** 30 x 45 cm (12 x 18 in)

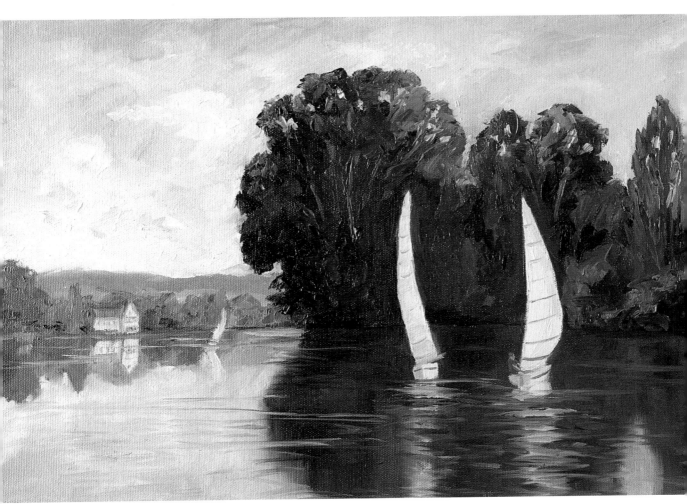

Flowers in the Landscape

As an artist, to come across flowers as part of the landscape is a particular joy, whether a dappled carpet of bluebells in an English woodland in springtime, a field of ripening sunflowers in Provence, dazzling in the afternoon light of late summer, or the view of a meadow covered with poppies near to my home – all of these sights make me want to paint.

◀ **Poppy Field**
25 x 31 cm (10 x 12 in)

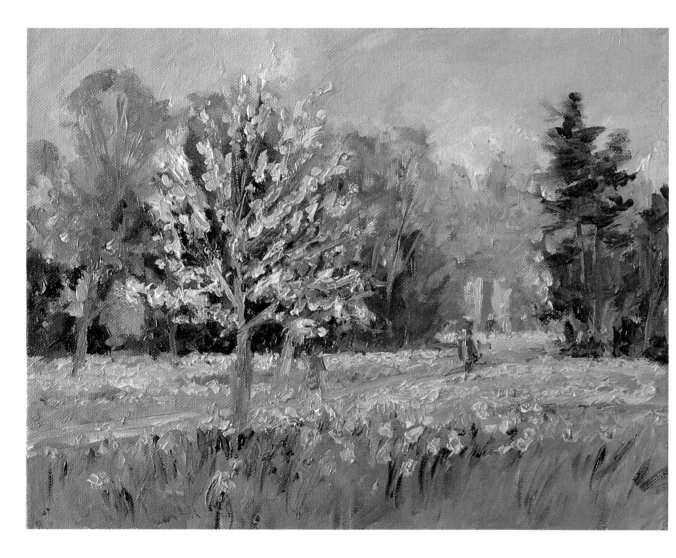

▲ Springtime, Hampton Court Gardens
25 x 31 cm (10 x 12 in)
A display of daffodils en masse makes an irresistible subject. Here, only the foreground flowers are painted in full. I used splashes of yellow and white amongst the green parkland to give the impression of flowers receding into the distance.

LOOKING AT FLOWERS

Flowers grow in all sorts of different situations and, equally, the artist can feature them in many kinds of painting, from a simple still life to a riot of colour in a garden scene. The following pages concentrate on a few types of flower that you are likely to come across in the open landscape and show how to incorporate them into a successful composition.

Planning compositions

It is easy to become completely enchanted by the flowers themselves, with little thought to the composition of the whole painting. When painting flowers as part of a landscape it is particularly important to ensure that they look right within the context of the painting, rather than as elements that were added in at the end. When you first sit down to paint a floral landscape, the key question to ask is, 'Do I want the flowers to dominate the whole painting, or to be a subtle extra?'. As you will see from the compositional sketches shown here, both ideas work well, provided you plan a little at the beginning.

◀ Here the sunflowers dominate the scene, with the background church adding a focal point.

Individual flowers

Before you start to include flowers in your landscape paintings, it is helpful to look more closely at those flowers that are familiar to you and that you will probably see in the countryside. Keeping a flower sketchbook can be very helpful, providing a useful source of ideas for the future. Sketches need not necessarily be in oils; simple pencil notes or watercolour sketches will be just as valuable as reference.

◀ Springtime flower studies

POPPIES

Poppies are a fairly simple flower shape, usually having six overlapping petals and leaves that grow straight out from the main flower stem. When seen in a meadow only the vibrant red flower heads or purplish seed pods appear from amongst the grasses. This makes them fairly easy to paint and since these colourful flowers need very little detail to make them look realistic they are ideal for the beginner.

exercise

Copy my poppy study (right). Mix a little Alizarin Crimson with Cadmium Orange to create a bright red for the flower shape, add a little Coeruleum for the highlights and use Alizarin Crimson on its own for the darker petals. Paint the central dark blotch using a mix of French Ultramarine and Light Red. The three-pronged leaves are Viridian and Raw Sienna for the dark tone, with Viridian and Lemon Yellow for the brighter green.

▼ **The White House**
20 x 25 cm (8 x 10 in)
The whole meadow was painted first, and the poppies added last with single brushstrokes of pure red tones. The flower centres were indicated where they could be seen, and the poppy stems blended into the wet colour of the meadow. This helped keep the red colours vibrant. A sense of distance was created by painting larger flower heads in the foreground.

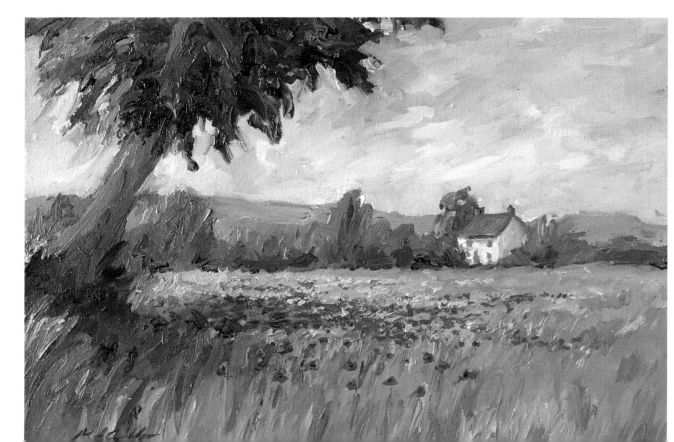

BLUEBELLS

Bluebells are a particularly English phenomenon, and the best time to visit a bluebell wood is during April when the flowers should be at their very best. The carpet of blue and purple under a light canopy of fresh green leaves is an absolute delight to any artist.

Getting the colour to look realistic for bluebells, however, is not easy. Contrary to popular belief, they are not really blue – more a blend of purple, pink and blue. To achieve a natural-looking colour, mix several different shades of blue tone, using French Ultramarine, Alizarin Crimson and white, and paint the flowers using all of these colours. The key point to remember is that all the bell-shaped flowers hang from one side of the stem, bending the stem itself over in a curve. Leaves are a soft grey-green shade (mix Viridian with French Ultramarine and white for these) and are long and thin, rather like grass stalks.

▲ **Kingswood Bluebells**
41 x 41 cm (16 x 16 in)
In a woodland scene such as this it is difficult to distinguish individual flower heads but very obvious if the overall blue shade is not quite right. I used a blend of French Ultramarine, Alizarin Crimson and Coeruleum with some white for my bluebell colours.

When incorporating bluebells into a woodland scene, concentrate on getting the colour right and remember to vary the blue shades to create the effect of sunlight filtering through the trees above. Only the flowers in the foreground will need to show individual bell flower shapes; further back in the woodland a blend of colours can create the impression of flowers rather than too much detail.

◀ **Bluebells**

LAVENDER

This blue flower is found in much warmer climates as well, where it is grown as a commercial crop rather than as a garden flower. Lavender crops provide another interesting flower-based subject for painting.

The lavender is usually grown in rows, within individual clumps that look like a line of giant purple-backed hedgehogs. Look first at a single clump

▼ **Provençal Lavender**
41 x 30 cm (16 x 12 in)
This painting of lavender growing near Sisteron in Provence, France, captures the atmosphere of the flowers without showing detail. Individual flowers are only seen in the foreground, with dabs of colour creating the impression of more flowers further back.

▼ Lavender

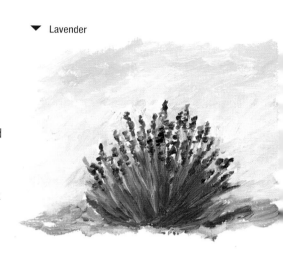

of lavender to observe the flower; tiny bud-like flowers are clustered at the top of fine stems. Leaves are grey-green in colour, thin and spiky. To paint a clump of lavender, start off with a mix of Viridian, French Ultramarine and white. Paint the basic overall shape with a No. 4 flat brush, remembering to create 'spikes' towards the edges. Lighter green stems can be added to one side with a fine round brush and a little Lemon Yellow added to the mix. Create each flower with a series of dots from the top of the flower stems downwards using the same brush and a dark purple mixed from French Ultramarine and Alizarin Crimson. The purple shade can be lightened with white to add a few highlights to some flowers to bring them to life, concentrating particularly on those flowers on the same side as the lighter green stems.

When painting the earth in between the rows of lavender, try a mix of Raw Sienna, Cadmium Orange and white for the basic soil colour. Add brushstrokes of pure Coeruleum on top of this wet paint for subtle shadows and to add texture.

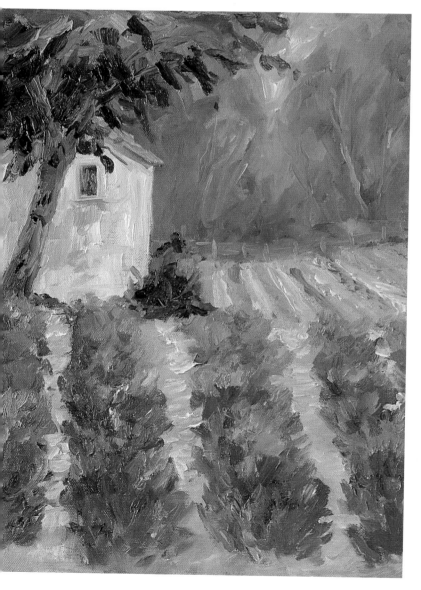

SUNFLOWERS

Sunflowers are one of my favourite subjects for painting. They are also particularly easy to paint well in oils and so form the basis for the demonstration on pages 80–83. Once again, you will need to consider the basic structure and colours first of all.

In early summer the flower heads appear with small dark yellow centres. As the season moves on the heads begin to ripen, turning much darker and swelling up as they do so. By September the flower heads look much larger with dark brown/blackish centres, making a wonderful contrast to the bright yellow outer petals. Leaves are mid green to grey-green in colour on thick stalks.

It is a good idea to choose and mix all the colours you will need before you actually start painting. You will need several yellow shades for the petals – pure Lemon Yellow, pure Cadmium Yellow and Raw Sienna. French Ultramarine mixed with Light Red makes a good dark tone for the centres of the

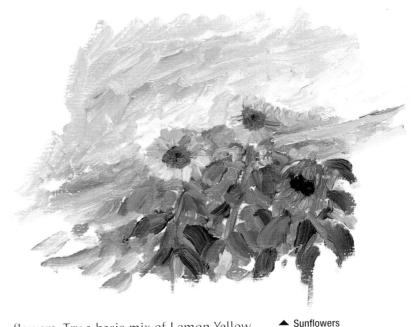

▲ Sunflowers

flowers. Try a basic mix of Lemon Yellow and Coeruleum for the leaves.

Several circular shapes are painted for the centres of the flower heads, using a No. 4 flat brush loaded with a dark 'black' tone. The petals are added using both Lemon and Cadmium Yellows. Use single brushstrokes from the centre outwards to create each individual petal. Leaves are also single brushmarks linked together with thin lines for the stems.

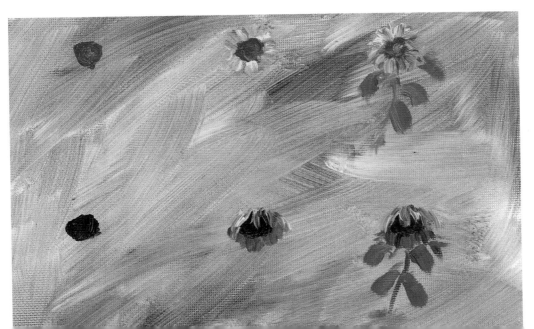

◄ The technique for painting individual sunflower heads whether facing the sun or bending over is the same. Start with the flower centre, adding yellow petals all the way round. Sunflower heads are large flowers, so remember to add some darker petals at the bottom using Raw Sienna to show petals shaded by those at the top of the flower. Then paint the main leaves and stem.

demonstration
Sunflowers near Benon

Sunflowers ripening in the late summer heat are such a delight to paint. In order to create the shimmering effect of a field of sunflowers in the breeze, I chose to paint on a thin wash of Alizarin Crimson. This cool pink shade provides an excellent contrast to the warm yellow tones of the flowers themselves. A sense of scale and recession into the distance are important elements in this painting.

you will need

canvas 25 x 30 cm (10 x 12 in) (primed with acrylic Alizarin Crimson)
brushes: No. 8 short flat, No. 4 short flat, No. 4 round, No. 10 short flat

colours

French Ultramarine, Light Red, Cadmium Orange, Yellow Ochre, Lemon Yellow, Cadmium Yellow Deep, Raw Sienna, Coeruleum, Viridian and Titanium White.

tips

◆ Form the actual flowers from the texture of the brushstrokes.

◆ Allow some of the pink underpainting to show through in places to help create a sense of movement.

◆ Create a sense of distance by including much more detail in the flower heads of the first two rows, but reducing these details so that they become a series of abstract brushmarks towards the horizon.

◆ Paint the sky before starting to paint the sunflowers. This makes it easier to judge the yellow tones rather than having too much pink underpainting still visible.

▲ **STEP ONE**

My initial sketch set out the background hillside and buildings to establish the basic composition. The pattern of sunflowers is roughly indicated with a series of circles. Note how the first two rows of flower heads are much larger than those further back to create a sense of scale within the sunflower field, helping it to recede into the distance.

◀ **STEP TWO**

First I primed the canvas with a thin wash of acrylic Alizarin Crimson and allowed this to dry. Using French Ultramarine and a No. 8 flat brush, I marked in the horizon line and distant hillside, making sure that the tree on the right-hand side broke through the top of the hill. This set the scale for the background. Flower heads are simple dots of Light Red and French Ultramarine at this stage, but I remembered to make the foreground flower heads much larger than those further back to create a sense of distance.

▶ **STEP THREE**

Next I painted the far hillside using French Ultramarine greyed down with Cadmium Orange and white. Greens for the middle hill were a mix of Viridian and Yellow Ochre with some Coeruleum added. The buildings were painted with a No. 4 flat brush, using Yellow Ochre, Cadmium Orange and white.

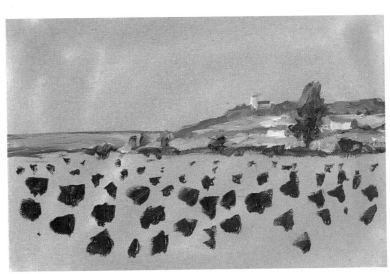

◀ **STEP FOUR**

Having established the horizon line and middle distance hillside, I could paint the sky. I used a No. 10 flat brush and a mix of French Ultramarine and Coeruleum at the top, but added white further down. Clouds were painted using Coeruleum, Cadmium Orange and white. I kept the brushstrokes loose, being careful not to paint a hard edge all round each cloud. I added a very thick highlight, using white with a little Cadmium Orange, to the top of each cloud, and used my finger to soften the darker bottom edge.

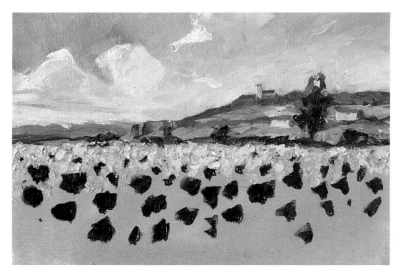

� STEP FIVE

Using a No. 8 brush with Lemon Yellow and white, I marked in random dots and small brushmarks for the top of the sunflower field. Actual flowers are not visible when they are so far in the distance. I mixed Lemon Yellow, Coeruleum and white for a soft pale green and added a few more dots in between the yellow ones for the leaves.

▶ STEP SIX

I used a No. 4 flat brush turned on its edge to paint the flower petals. I started with the shadow petals at the bottom using Raw Sienna, then added lighter petals around, using Lemon and Cadmium Yellow Deep. The middle hillside now appeared too dark, so I used a bright green and Lemon Yellow to overpaint the hedgerow and main tree on the right-hand side, using a No. 8 flat brush. Windows and doorways on the buildings were added with a No. 4 round brush, using the same grey as for the distant hill.

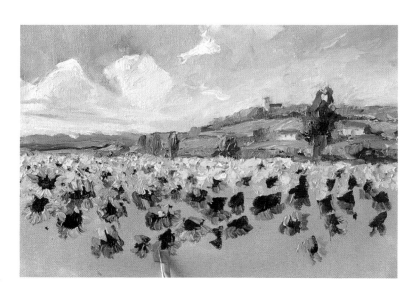

▲ STEP SEVEN

Once I had painted flower petals around all the dark heads, I used a No. 8 flat brush to add more leaves in between the flowers and towards the bottom of the canvas. Each leaf was produced by a single directional brushmark, helping to create an overall impression of movement rather than too much detail. Finally, I left plenty of unpainted canvas towards the bottom of the picture to paint in foreground soil.

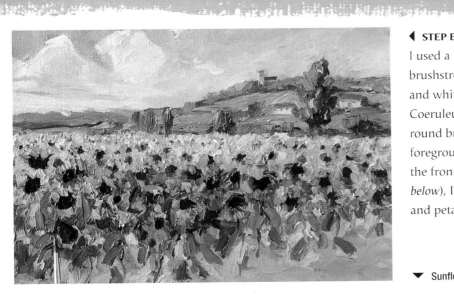

◀ STEP EIGHT

I used a No. 8 flat brush and loose brushstrokes to paint the earth. Raw Sienna and white formed the basic tone, with a little Coeruleum added for shadow. With a No .4 round brush I tidied up some of the foreground leaves and added a few stems to the front row of sunflowers. Finally (*see below*), I restated any of the sunflower centres and petals that had become obscured.

▼ **Sunflowers near Benon** 25 x 30 cm (10 x 12 in)

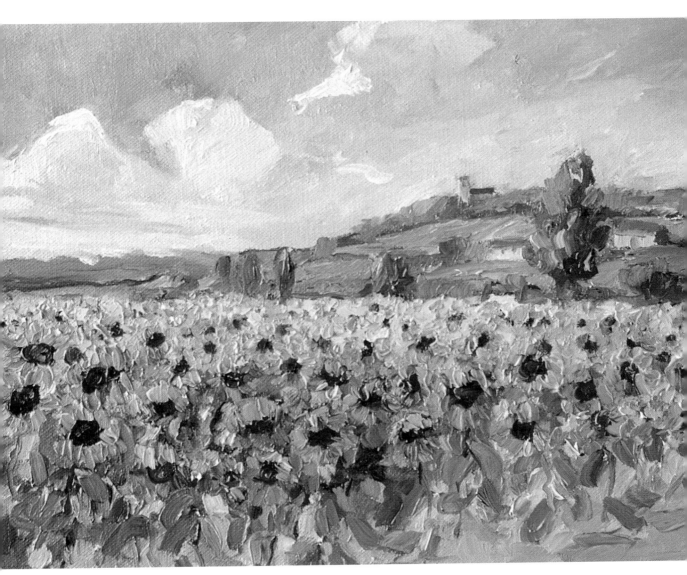

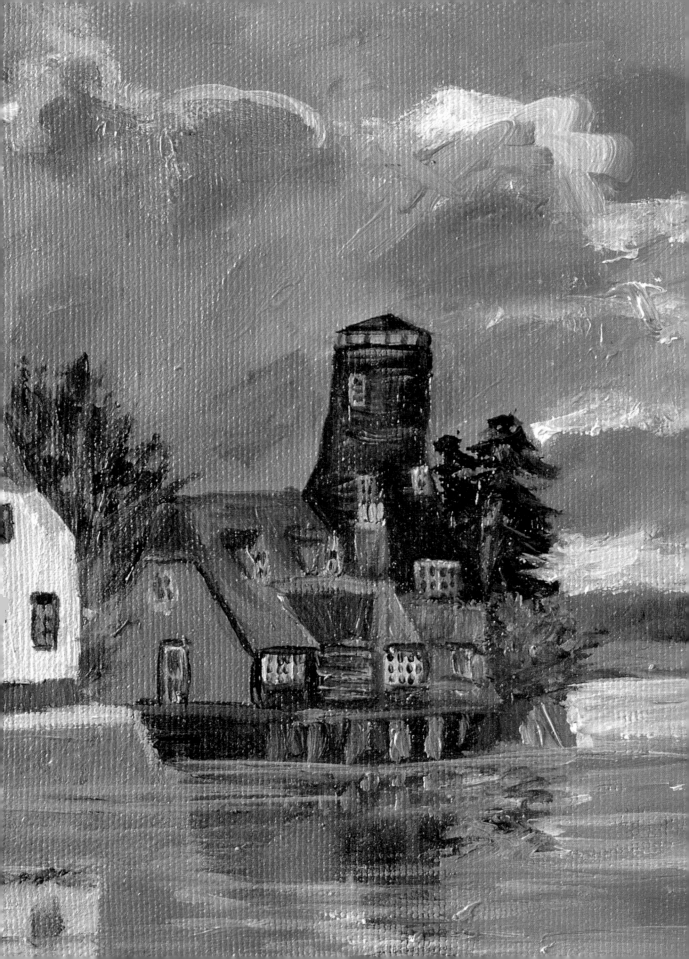

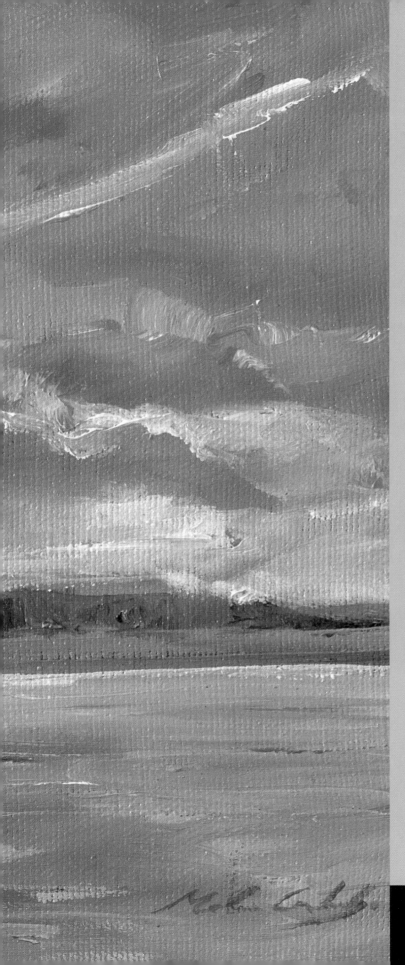

Buildings in the Landscape

Buildings are an integral part of the landscape, so it is an advantage to feel fairly confident in painting them. While there are some points of perspective to bear in mind, the subject can be simplified to an understanding of basic shapes and proportion. Using simple methods of measurement will enable you to tackle buildings even if you find line drawings difficult.

◀ **Watermill at Langstone**
20 x 25 cm (8 x 10 in)

▶ Start by painting a basic square shape. Then darken the red with a little Viridian, or the complementary of whatever colour you have chosen, and paint the side. Finally, use your lightest tone to paint the top and complete the cube.

WORKING WITH CUBES

Most buildings are made up of a series of block shapes in reality, so start by painting these rather than worrying too much about the outlines. By breaking down each building into these blocks and other shapes, it is possible to 'build up' the finished shape from within. This approach of building with paint rather than relying on a basic outline is the key to painting many complex objects successfully.

Most students will recognize the basic cube. A cube or rectangular shape, together with other shapes, can be used to create a building; for example, a church. This simple method will help you approach buildings that are to be painted in the middle distance and do not require much detail.

▶ Using flat shapes, take a little Raw Sienna and paint a tall rectangle for the church tower, placing a long rectangle alongside it for the actual church. The roof shape is painted with a grey tone mixed from French Ultramarine, Cadmium Orange and white.

▶ The tower looks three-dimensional with a thinner flat shape alongside (white added to Raw Sienna). Windows are single brushmarks in a darker mix of the roof grey. A line of darker grey along the edge of the roof indicates the shadow of the overhanging tiles.

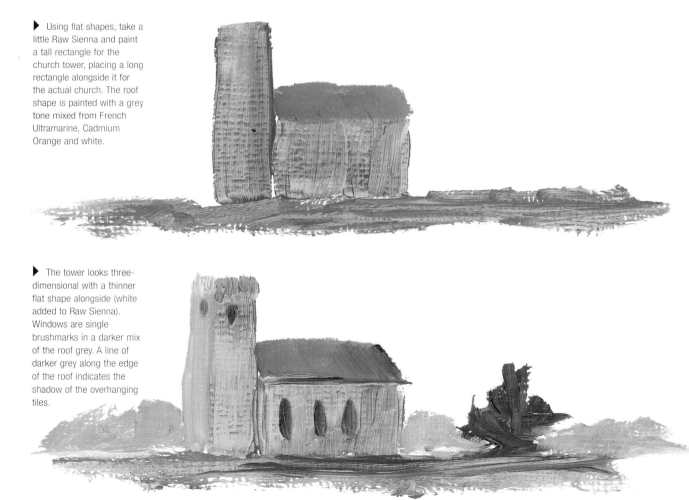

BASIC MEASURING

The other key element in painting a successful building is to ensure that the scale is correct in proportion with the rest of the landscape. This can be achieved using a simple pencil measurement. First hold a pencil at arm's length between thumb and forefinger. Look along the pencil at your chosen subject and pick out a 'key measurement' (maybe the side of a building or a handy telegraph pole). Use your thumb to mark the measurement on the pencil.

Having established a single base unit of measurement, simply use this to measure other aspects of the building; for instance, the length of the barn is

two units, the wall is one and a half units etc. With practice you may find yourself dispensing with careful measuring by pencil and find that using your eye will become enough.

tip

- *While measuring, also check the angle of each line in relation to either the horizon line or vertical edge of the page.*

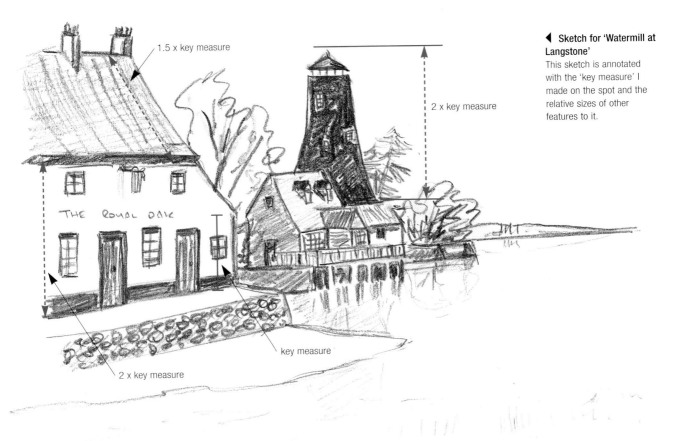

◀ **Sketch for 'Watermill at Langstone'**
This sketch is annotated with the 'key measure' I made on the spot and the relative sizes of other features to it.

1.5 x key measure

2 x key measure

THE ROYAL OAK

key measure

2 x key measure

GROUPS OF BUILDINGS

Moving on from painting a single simple building to painting a whole street or village should not change the initial approach. The overall subject may seem more complicated, but by starting with block shapes, then adding details such as chimneys and windows, the whole street can often be treated as a single building.

▼ Start by painting the basic block shapes, concentrating on the main walls and roof angles.

WINDOWS, DOORWAYS AND OTHER DETAILS

Windows, doorways and chimneys show the character of a building, particularly when it is an old or historical one. Getting these details correct ensures your finished painting looks right. In my view of *Brasted Tea Rooms* the windows are of different sizes and at different levels, particularly on the first floor. This is not a mistake; they actually were like that! Observation of such detail is important; the offset windows give the impression of an old cottage shop – exactly what the building was.

Unless you are working on a large scale, most building details will probably be less than 2.5 cm (1 in) high in your paintings. Windows need only be a dark

▲ **Brasted Tea Rooms**
(detail)
The windows were first painted in a dark tone. Then paler window frames were added on top using a No. 4 round brush.

▶ **Brasted Tea Rooms**
25 x 31 cm (10 x 12 in)

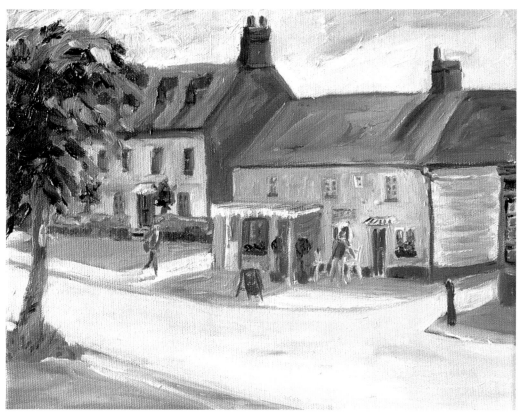

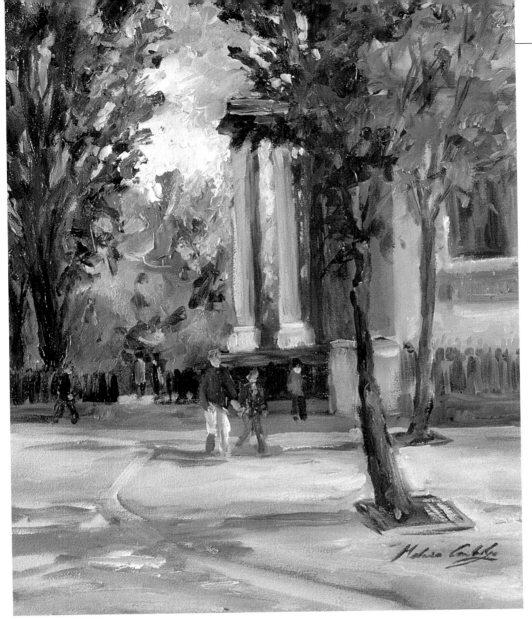

◀ **Behind St Paul's**
31 x 25 cm (12 x 10 in)
This view of St Paul's Cathedral was painted on location in fairly cold, windy conditions. Note how the foreground figures add a sense of scale.

▼ Details on the stonework were kept to a minimum, using a mix of Yellow Ochre, Coeruleum and white.

rectangle, with paler lines indicating the framework. Doorways are also painted as a small block, using an initial dark tone; French Ultramarine and Light Red make a good starting point. I used this method to paint the cottage windows and door for *Brasted Tea Rooms*.

When painting the stonework on *Behind St Paul's* I used the individual brushmarks to create the textures around the main window, varying the strength of colour to add extra interest. A No. 4 flat brush was ideal for this purpose.

tip

♦ *When painting white features, tone down pure white with a little French Ultramarine. In this way you can reserve pure white (or even white with a touch of Lemon Yellow added) for the highlights.*

demonstration
Roussillon, France

Incorporating buildings into the landscape can be a daunting prospect. In this painting of a French village at Roussillon, perched high on the famous red/ochre cliffs, the village forms the focal point, but, because it is in the middle ground, the buildings can be reduced to simple block shapes, with details added later. The final result is a successful painting, produced using very simple techniques.

you will need

canvas 35 x 40 cm (14 x 16 in) (primed with acrylic Burnt Sienna)
brushes: No. 8 short flat, No. 4 short flat, No. 4 round, No. 10 short flat

colours

French Ultramarine, Light Red, Cadmium Orange, Yellow Ochre, Viridian, Coeruleum, Alizarin Crimson and Titanium White.

tips

• *Paint the whole wall of each building with a single brushstroke if possible.*

• *Paint the cliffs with loose brushstrokes, working in different directions to give an impression of texture to the rocks.*

• *Try to ensure that the shadow sides of each building reflect light coming from the top right of the canvas.*

• *Windows should be slightly darker than the surrounding building colours.*

• *Add shutters to some windows to give some individuality to different buildings.*

• *Do not forget to paint the chimneys.*

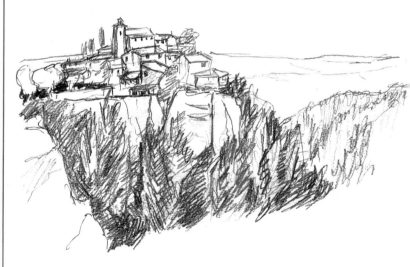

▲ STEP ONE
This view across the valley towards Roussillon was sketched while on holiday. Having parked the car for a few moments there was just time to note down the basic composition, adding a few notes alongside to remind me of the brilliant colours of the red cliffs and dark shadows in the forest below.

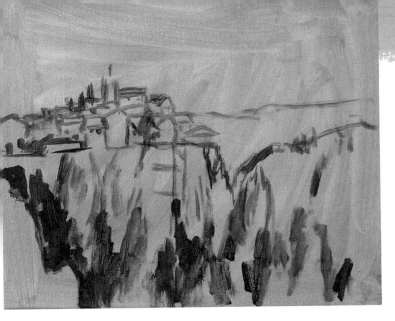

◀ STEP TWO

I primed my canvas with a thin wash of acrylic Burnt Sienna. Then I marked in the basic composition with a No. 8 flat brush using French Ultramarine. The buildings are indicated with simple outlines, while the foreground trees are blocked in as flat blue tones. These would form the darkest area of the finished painting.

▶ STEP THREE

Still using the No. 8 flat brush, I painted in the buildings as basic block shapes. I started with a mix of Cadmium Orange and white for the lightest sides of the buildings, then added French Ultramarine to this mixture for the shadow sides. I painted roofs to each building in the village using the same technique, but this time with a mix of Cadmium Orange and Yellow Ochre for the lighter roofs, and Light Red and French Ultramarine for the darker shadow sides.

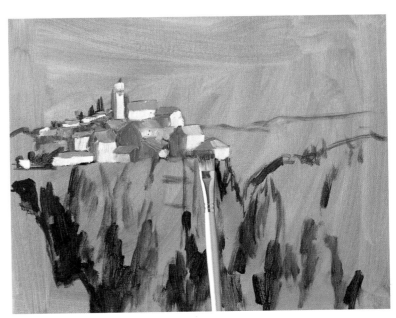

◀ STEP FOUR

Next I blocked in the cliffs. I used Light Red and French Ultramarine for the basic cliff tone, but added Cadmium Orange and Yellow Ochre for the lighter tones. The foreground rock face was also painted at the same time. In a picture like this it is important to ensure that the middle cliffs are a little paler than those in the front left-hand corner in order to create a sense of distance.

▶ **STEP FIVE**

I blocked in the background hills, starting with the furthest and using a soft grey mix of French Ultramarine and Cadmium Orange with plenty of white. Then I blended in a little extra French Ultramarine and Viridian to create the impression of a distant forest. For the second hillside, I added Viridian and Yellow Ochre to the original grey mix for a stronger green. I created the conical tops of the trees with the edge of the No. 8 flat brush.

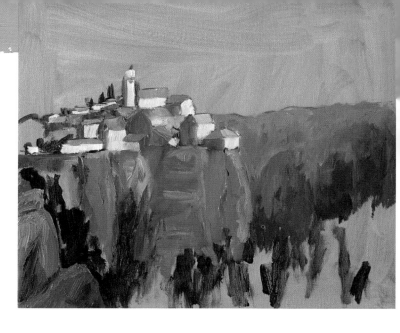

◀ **STEP SIX**

Now I could paint the sky. I used a No. 10 flat brush, starting at the top of the canvas, with a mix of French Ultramarine, Coeruleum and white. The effect I wanted was produced with soft brushstrokes, blended by working fairly rapidly. As I painted towards the horizon I added more white and a little Cadmium Orange to the mix and used the sharp edge of the flat brush to paint right up to the edges of the buildings.

▶ **STEP SEVEN**

Once the sky was complete I could add windows and other details to the buildings. I used French Ultramarine greyed down with Cadmium Orange and applied the paint with a No. 4 round brush. I painted each window as a single line initially and remembered to put a shadow line under the eaves on some of the roofs. Shutters for some of the windows were also produced with a single sideways brushmark, using a No. 4 flat brush.

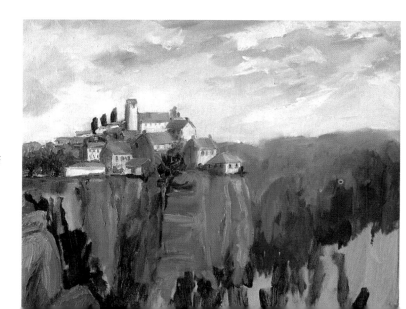

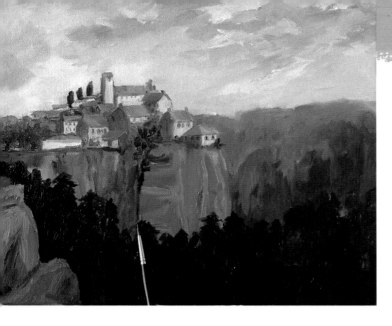

◀ **STEP EIGHT**

I blocked in the foreground trees using Viridian and Alizarin Crimson for the darkest greens, and added Yellow Ochre for the lighter tones, then painted the feathery tree tops. Finally (*see below*), I painted the tree trunks with Light Red and Yellow Ochre, and added two figures under the trees to the far left of the village.

▼ **Roussillon, France** 35 x 40 cm (14 x 16 in)

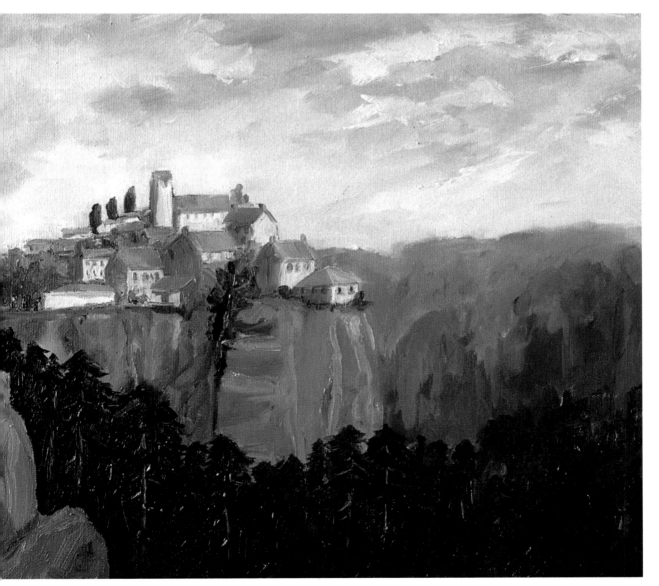

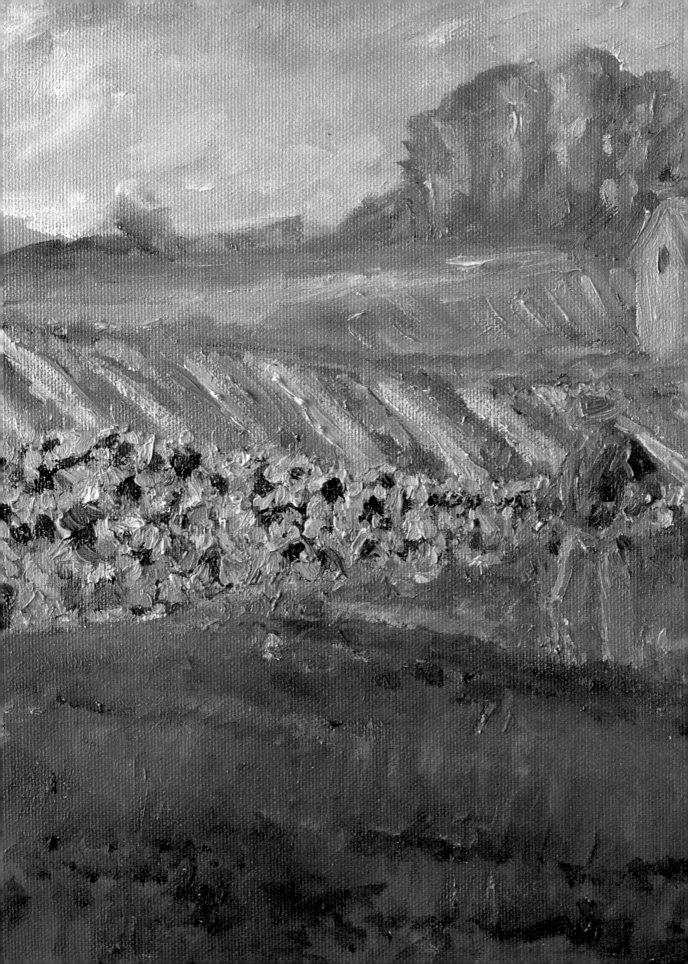

Figures in the Landscape

Being able to add a few figures into your paintings will bring them to life. Even in the quiet of the countryside it is rare not to see anyone about – maybe a farmer, a walker or someone riding a horse. This chapter looks at how to paint realistic figures in the middle distance and how to incorporate them into your paintings successfully.

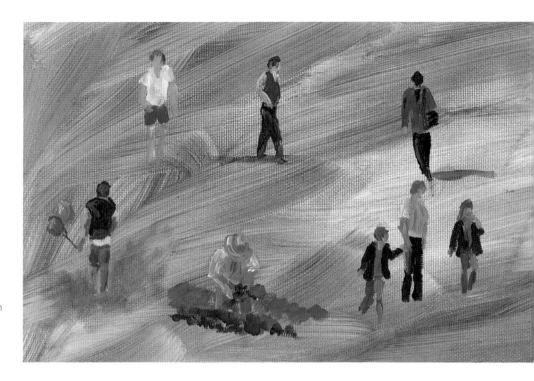

▶ These figures have been painted very simply with just a few brushstrokes. Paint lots of similar studies to help build confidence.

SIMPLIFYING PEOPLE

Again, rather than starting with an outline, try to think of people as a series of shapes and brushmarks. I always start with the body, then add the head, legs and finally the arms. To avoid worrying about the shape of a nude figure, paint the clothes instead. This way you can build up a reasonable figure shape by painting, say, a T-shirt and then long trousers, helping to establish the basic figure before adding the arms and head. Where the figure is moving, the angle of the torso, and then of the legs, establishes the stance much more descriptively than the head.

▲ Start with the torso of the figure and use a medium flat brush to paint a basic T-shirt. I have used a very pale blue mixed from white with a little French Ultramarine.

▲ Add the trousers, using French Ultramarine darkened with a little Cadmium Orange.

▲ Mix a flesh tone from Cadmium Orange, Raw Sienna and white to add the head and arms.

▲ Use a little dark brown, mixed from Light Red and French Ultramarine, to paint the hair. Finish the top of the trousers with darkened blue and add a little more shading to the T-shirt. There you have it – a simple figure to paint in the middle distance.

| Front view | Back view | Looking left | Looking right |

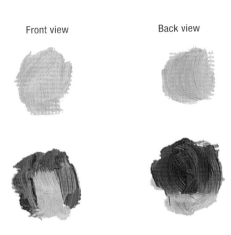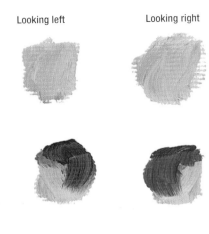

◀ Start with a single brushmark to indicate the head, using a flesh tone mixed from Cadmium Orange, Raw Sienna and white.

◀ Add the hair to indicate the direction of the figure.

▼ Make lots of quick sketches of children to help 'tune in' your eyes to the differences in the scale of proportions between adults and children. This will help make your paintings of children look more realistic.

HEADS AND FACES

When painting figures in the middle distance as part of a landscape or street scene it is not necessary to paint the faces. Adding facial details at such a small scale can sometimes make the figure appear rather comical, as can painting feet. Instead, use the angle of the head and the hairline to indicate which way the figure is facing.

When adding the hair use only single brushstrokes to avoid picking up any underlying flesh colour. Wipe off any unwanted colour between each brushstroke as you work.

CHILDREN

When painting children you need to be aware of slightly different proportions. While adults have a head that is about one seventh of the full height, children under twelve have a somewhat different ratio, with the head being approximately one fifth of their full height. Getting the proportions right for children will make them look natural rather than appearing to be very small adults.

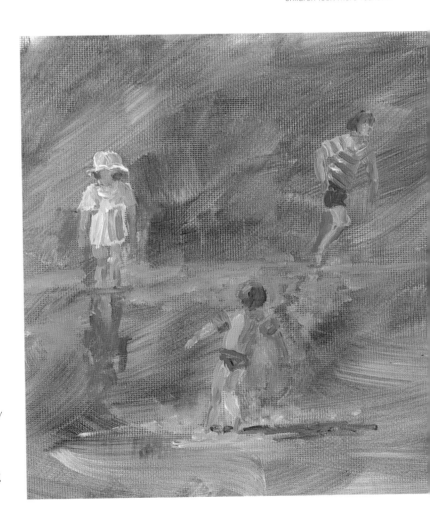

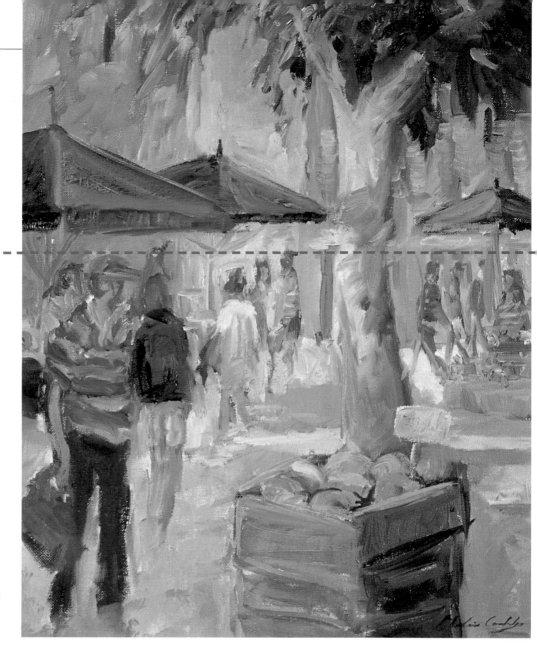

▶ Melons à Vendre,
Bourgeneuf
46 x 36 cm (18 x 14 in)
When figures are seen on level
ground the heads will line up
across the horizon, as
indicated by the dotted line.

tips

◆ *An easy mistake is to paint a figure too
large or small for a doorway, so do be
aware this.*

◆ *Avoid painting feet as this often makes a
figure appear static
and rather
comical.*

FIGURES IN SCALE

Figures will only look realistic in your
paintings if they are in correct
proportion both to their surroundings
and to other figures in the painting. This
is not as complicated as it sounds.
Provided they are on level ground,
perspective will ensure that all the heads
of your figures should more or less line
up. This means in practice that figures
nearer to the front of the painting will
appear larger in size, but their heads will

still be level with those further away and consequently smaller in size. The painting of *Melons à Vendre, Bourgeneuf* on page 98 shows this.

SIMPLIFYING GROUPS AND ANIMALS

When tackling a group of figures you can sometimes paint them as one shape, with a few details added. Alternatively, if you paint separate figures standing close to each other, make sure some of them overlap. Try to avoid depicting figures just touching each other as this makes it difficult to see which figure is in front of the other.

People in the countryside are often accompanied by a dog, which you will want to include. Again, there is no need to paint in the fine detail of the animal; the key is to capture its movement and character. Concentrate on getting the proportions of the dog right – the size of its body compared to its legs, for instance. Make sure that the dog is in scale with any figures in the painting.

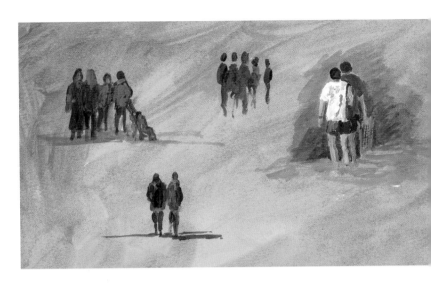

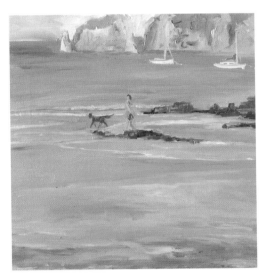

▲ When painting groups of figures look at the overall shape and paint this first, adding the heads afterwards. Take care when painting figures close together to overlap them so that it is obvious which one is in front of the other.

◀ **Beach Dog**
31 x 31 cm (12 x 12 in)

▲ Start with the body, using a medium flat brush loaded with Light Red. Most dogs have a fairly rectangular body, with a smallish head.

▲ Add the tail and legs using a No. 4 round detail brush. Try to paint the legs with just one brushstroke and do not worry about adding the feet.

▲ Having established the basic outline of the dog, add some patches of white to define the shape of the body. Use a little French Ultramarine to shade under the dog's stomach. A touch of white on two of the legs and the nose for highlights finishes the painting.

demonstration
Low Tide, Daymer Bay

The beach is a great place to paint figures. There are usually plenty of people moving around or just relaxing, making it easy to include them in your paintings. It is helpful to note down any key colours of T-shirts, towels, dogs etc. Most people who visit the beach are on holiday and will often stay all day, so settle down in a quiet corner to sketch them before including them in your finished painting.

you will need

canvas size 30 x 45 cm (12 x 18 in) (primed with acrylic Burnt Sienna) brushes: No. 8 short flat, No. 4 short flat, No. 4 round, No. 10 short flat

colours

French Ultramarine, Light Red, Cadmium Orange, Sap Green, Lemon Yellow, Raw Sienna, Coeruleum and Titanium White

tips

◆ *Use both the flat and sharp edges of the brush to create different textures within the cliff face.*

◆ *Use Cadmium Orange and white darkened with a little Raw Sienna for a basic flesh tone.*

◆ *Paint the figures first, before you paint the beach. This enables you to correct mistakes without having to repaint the surrounding beach each time.*

◆ *Check the angles of reflections, especially those of moving figures. Do not forget that the dog has a reflection as well!*

◆ *Vary the tones of the foreground beach to show areas of wet and dry sand.*

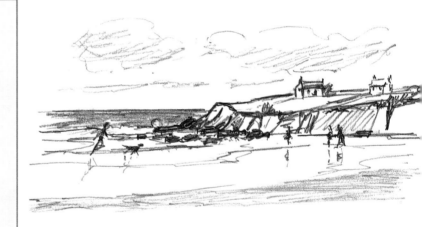

▲ **STEP ONE**
My initial sketch of the beach at Daymer concentrated on the composition with its low cliff and cottages perched on the edge. As figures moved about on the beach in front of me I noted their positions relative to my sketch. I then made a few separate figure sketches as well.

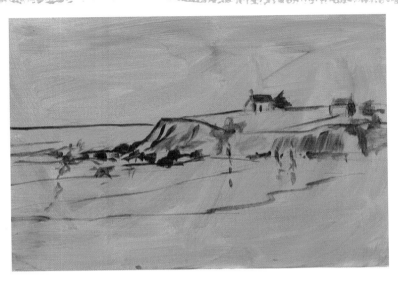

▶ **STEP TWO**

With so many cool blue shades in this beach scene, using a canvas primed with Burnt Sienna helps to counteract the coldness and give the finished painting an overall warmth. So, working on a tinted canvas, I laid in the basic composition with a No. 4 flat brush using French Ultramarine. The four figures and the dog are simple shapes of the right scale – just a head, body and single brushstroke for the legs.

▶ **STEP THREE**

I started painting the background cliffs, using a No. 8 flat brush with a mix of Lemon Yellow and Coeruleum for the brightest green, softened with a little Raw Sienna in places. The red cliffs were painted with a mix of Light Red and French Ultramarine for the darker tones, with Raw Sienna and white for the lighter areas. Next I blocked in the two cottages, white for the sunlit wall, with French Ultramarine and Cadmium Orange for the shadow side. The roofs were the same mix, but with less white and more orange.

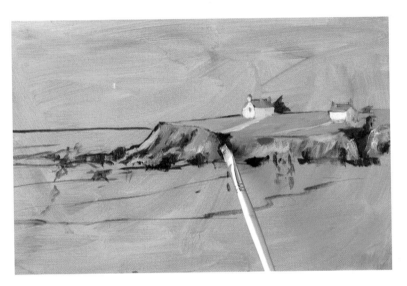

▶ **STEP FOUR**

After I had finished painting the cliffs I added the shrubs, using Sap Green and Raw Sienna. I blocked in the sea to the horizon using a No. 8 flat brush loaded with French Ultramarine and Cadmium Orange, placing flecks of white to give an impression of distant waves. For the sky I chose a No. 10 flat brush. I started with Coeruleum and white at the top, then painted the clouds using Coeruleum and Cadmium Orange for the shadow side, with white and Cadmium Orange for the sunlit tops.

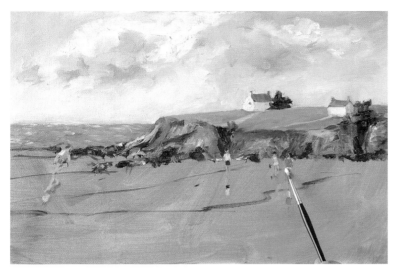

◀ STEP FIVE

It is considerably easier to paint the figures at this stage, working directly onto the blank canvas. Mistakes made now can be cleaned off without damaging any surrounding wet paint. I used a No. 4 round brush and, starting with the body in each case, built the figure, adding head, arms and legs. Using the same colours I also painted the reflection at the same time.

▶ STEP SIX

With the figures now established, I started to paint the surrounding beach and wave. I used a No. 8 flat brush as much as possible, but also a No. 4 round brush. Lemon Yellow and Coeruleum made a good mix for the wave and the shallow water as it falls onto the beach. Where the wave hits the rocks it is always tempting just to use pure white, but adding a little shadow area at its base gives the breaker more form.

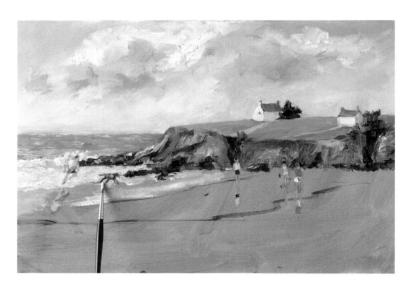

◀ STEP SEVEN

I painted the beach using a No. 8 flat brush and a basic tone of Raw Sienna and white, but with a little Light Red added towards the bottom of the canvas. With very light pressure on the brush, I added stripes of Coeruleum and white across this beach tone to give the impression of water running back towards the sea.

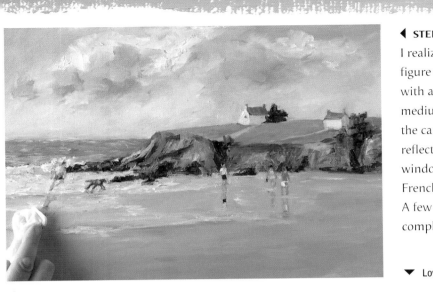

◀ STEP EIGHT

I realized that I had put the reflection of the figure on the far left at the wrong angle, so with a clean rag dipped in a little painting medium I gently wiped off the paint back to the canvas. Finally (*see below*), I repainted the reflection and surrounding beach. I added windows to the cottages on the cliff, using French Ultramarine and Cadmium Orange. A few rocks and stones on the beach completed the picture.

▼ **Low Tide, Daymer Bay** 30 x 45 cm (12 x 18 in)

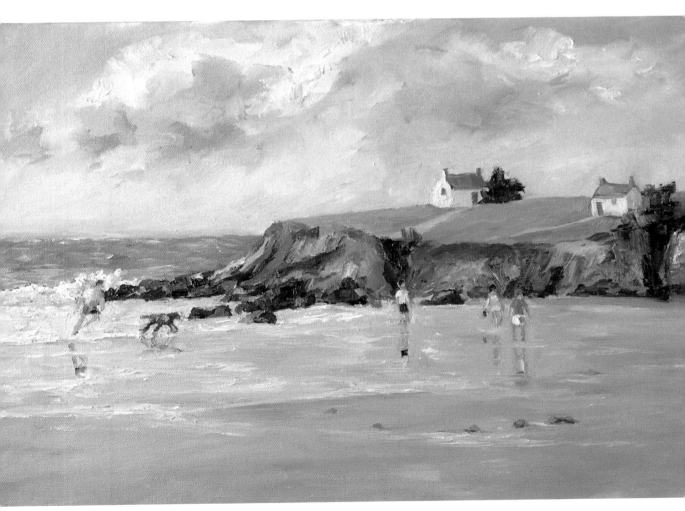

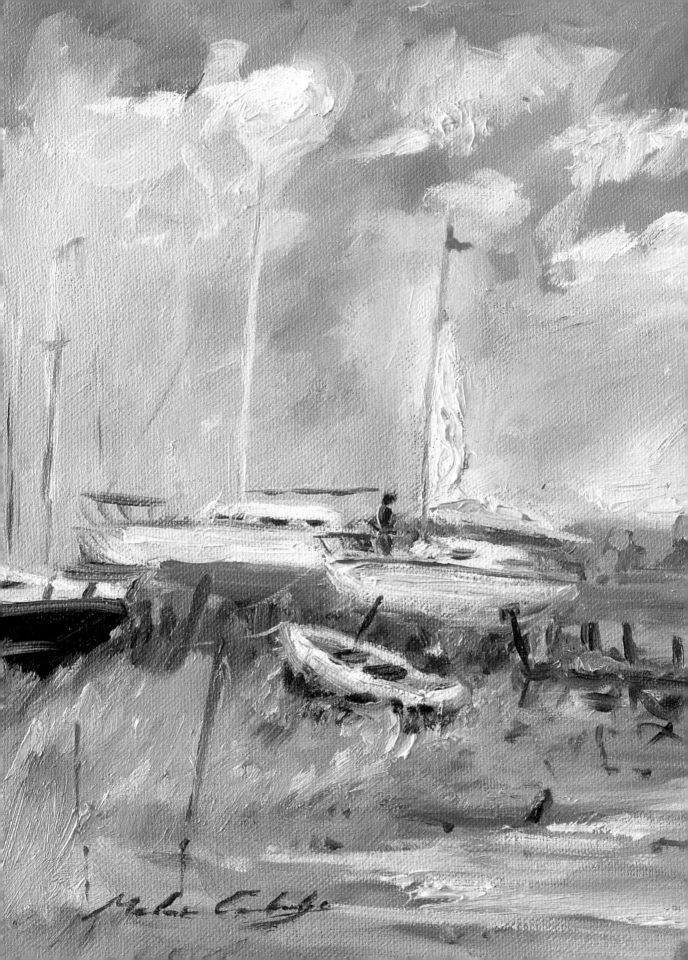

Boats and Harbours

Boats and harbours offer an almost limitless variety of material for the artist, from a single boat moored on a river bank to harbours with fishing boats, yachts and all the associated equipment of the waterfront. Let us look at each element separately to enable you to build up your confidence to paint from this subject, from a simple boat shape to a full harbour view.

◀ **Breezy Afternoon, West Itchenor**
25 x 31 cm (10 x 12 in)

LOOKING AT BOATS

When you first start to look at boats as a subject for painting, you begin to realize just how many different types and shapes there are, so it is very helpful to build up your knowledge by sketching the basic types. Some students find it difficult to draw the outline shape, so try instead to 'build' the boat shape from the outset by working in paint straightaway with no pre-drawing. Try to avoid thinking 'it's a boat, and I can't draw boats', but treat this subject as a series of block shapes instead. Use a No. 8 flat brush and a No. 4 rigger brush to sketch in each shape or surface almost like an abstract pattern. Gradually, as the shapes link together, the overall shape of the boat will begin to appear.

The example here of how to use paint to 'build' a basic yacht seen from the side shows you how to simplify a complex subject like a boat down to abstract shapes. The details are added towards the end. This alternative approach to painting should make it much easier to tackle more complicated subjects at a early stage in your artistic development without the fear of having to produce an accurate drawing before you start.

▶ Fill your sketchbook with as many different boats as you can for reference.

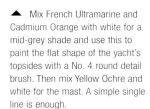

▲ Use a No. 4 flat brush loaded with Alizarin Crimson to paint the hull, ideally with only three or four brushstrokes.

▲ Mix French Ultramarine and Cadmium Orange with white for a mid-grey shade and use this to paint the flat shape of the yacht's topsides with a No. 4 round detail brush. Then mix Yellow Ochre and white for the mast. A simple single line is enough.

▲ Mark in the yacht's window by darkening the grey with a little more French Ultramarine. Paint the rolled up sail as a long stripe and add a spot of the mast colour at the end.

▲ Details are added in white – the rail at the front of the yacht and two fenders (painted directly into the wet red of the hull). Using the mast colour, add a series of lines to the sail to indicate the ties and, finally, indicate the stripe along the lower part of the hull with a little pure French Ultramarine.

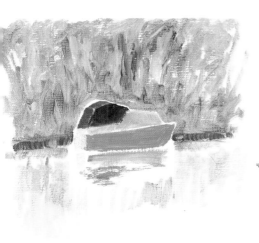

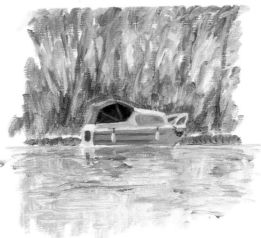

◀ **River cruiser**
The hull shape is a darkish tone, and the back of the boat is painted white. The shape for the topsides is in a lighter tone. The canvas cover is two flat shapes, in dark and light tones. Stripes are indicated on the side of the cover using the paler tone. The window is painted and then the frame, and a white rail is painted on the front. A dark area is painted into the back of the hull. Two laths on the hull sides are worked directly into the wet paint underneath and a curved fender shape is added to the front. Finally, two fenders are painted on the sides using white paint.

DIFFERENT TYPES OF BOATS

Now let us consider some other types of boat. An example of a river cruiser and a fishing boat are shown here. Notice how in the example of the river cruiser the boat's overall shape – its 'outline' – is complete without having done any drawing, but adding the details turns the fairly flat shapes into a finished boat.

Similarly the fishing boat starts out as a series of blocks, but because it has two colours in the hull two separate block shapes combine to give its outline. Details of the rigging are suggested rather than precisely painted, keeping the overall effect loose and lively.

Fishing boats seem to have an enormous amount of complex apparatus, but keep these details to a minimum to prevent them becoming too dominant in the painting. The finished result appears quite detailed, but these details are quite roughly painted using lively brushstrokes to keep the picture looking spontaneous.

tips

◆ To help build up your confidence sketch boats using a brush or thick marker pen that will enable you to use blocks rather than lines from the outset.

◆ When viewing boats from ground that is level with the water, there is not much distance between the boats and the far bank or horizon. Place your boats high up towards the horizon for a realistic effect.

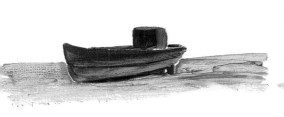

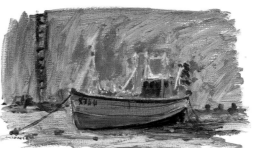

◀ **Fishing boat**
Start with the hull, painting the top section and keel as stripes. The boat is at a slight angle, so the stripes appear narrower towards the back. The cabin is a cube shape. Cabin windows are single brushstrokes and fishing floats are simple ball shapes. Other details are indicated sketchily.

▶ **Vieux Port, Honfleur**
25 x 31 cm (10 x 12 in)
This view of Honfleur in France was painted back in my studio using the photograph below.

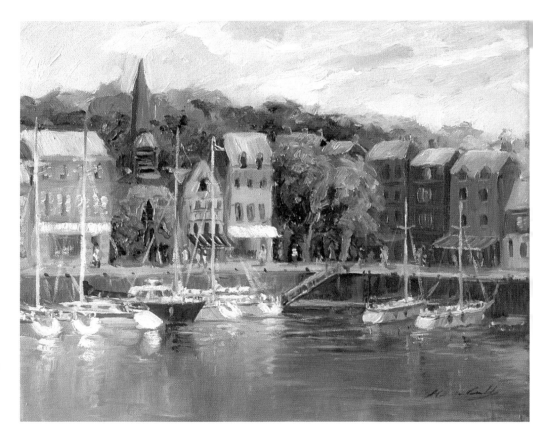

▼ Many of the details in this photograph have been simplified in the painting, especially the buildings in the background; including all the details would bring the buildings too far forward in the finished painting. Highlights are strongest on the foreground yachts and shop canopies.

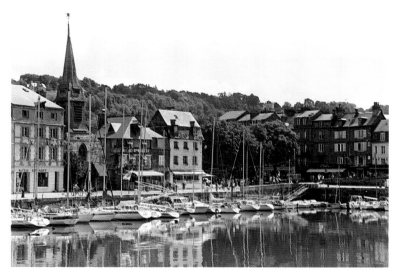

LOOKING AT HARBOURS

Harbours are full of activity, fishing equipment, cranes, buildings and, of course, lots of boats. Painting on location at a harbour can be quite a challenge, so it is useful to start off by working from photographs. Ideally, these should be photographs you have taken yourself or at least of a place you have visited, so that you are familiar with the scene.

COPING WITH THE DETAILS

Since harbours are such busy places it is essential to create this feeling of activity and clutter within your painting. This can mean including many unusual items such as cranes, fishing nets, lobster pots and packing crates as well as buildings and, of course, people.

A first visit to a busy harbour can be a rather intimidating experience for the amateur artist. There seems to be so much; but do not panic! There is no need to paint everything you see; just try to

create an atmosphere of paraphernalia and busy movement. Treat all of the items in the same way as the boats themselves, as abstract shapes to begin with, then adding a few extra details to bring them to life.

Look carefully at the sketch here (*right*) and you will see how each item has been simplified – most of the ropes and lines have been left out on complex equipment such as the crane. Fishing nets are simply suggested using a criss-cross pattern, while the floats are simple ball shapes with a loop on top.

Wherever there are boats and moorings there are usually people, working on the boats or simply walking along the waterfront. Adding a few simple figures, even just in the background, helps to bring marine paintings to life. Painting figures is covered on pages 94–103, but here are a few more ideas when relating them specifically to harbour scenes. Copy these simple studies if you wish before collecting your own ideas from sketches or photographs.

▲ A quick study of cranes, packing cases, nets and floats.

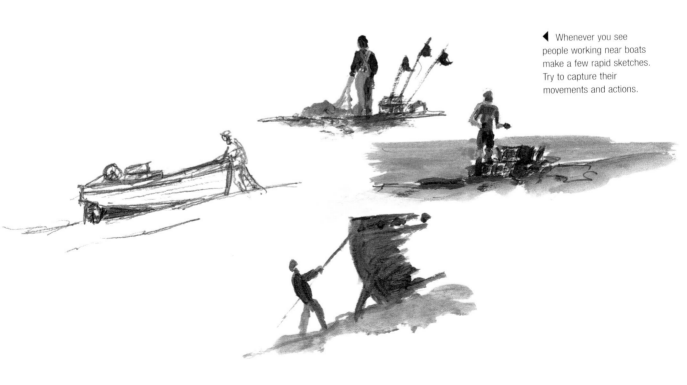

◀ Whenever you see people working near boats make a few rapid sketches. Try to capture their movements and actions.

demonstration
Oyster Boats, Ile de Ré

For this scene of fishing boats near to La Rochelle in France I decided to work on a background of Alizarin Crimson. The strong turquoise water in particular works well with the cool pink underpainting. I was attracted to the scene by the contrast of turquoise water against the white fishing hut and boats and the fact that the colours were so different from the soft tones of an English landscape.

you will need

canvas size: 25 x 30 cm (10 x 12 in) (primed with acrylic Alizarin Crimson) brushes: No. 8 short flat, No. 4 short flat, No. 4 round, No. 4 rigger, No. 10 short flat

colours

French Ultramarine, Light Red, Cadmium Orange, Sap Green, Lemon Yellow, Raw Sienna, Coeruleum, Alizarin Crimson, Viridian and Titanium White.

tips

• *Work fairly thinly when painting the sky to enable a little of the pink underpainting to show through and give the sky an overall warm glow.*

• *Try to see only the main block shapes within each boat when you start to paint them. Do not think about details at the initial stage.*

• *Make sure that the mast and the poles of the foreground jetty are all tall enough to break through the horizon line and into the sky.*

• *When adding the ripples onto the water use very light pressure on the brush to produce very fine lines.*

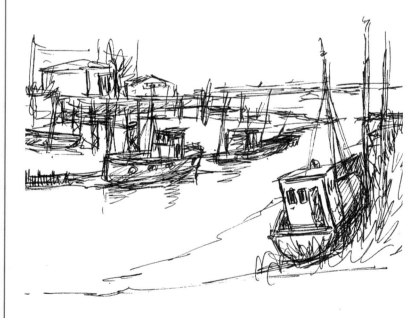

▲ **STEP ONE**

My sketch for this painting shows the basic composition and structure of the fishing boats. Notes alongside it reminded me of the key colours – strong turquoise water, predominantly white boats on the far side of the inlet, and a dark green foreground boat.

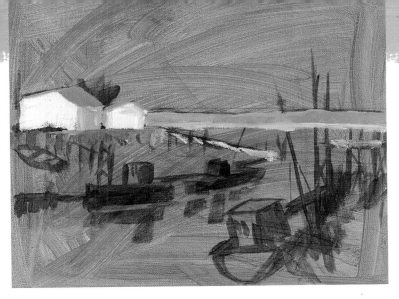

◀ STEP TWO

Having primed the canvas with a thin wash of acrylic Alizarin Crimson, I blocked in the main shapes with a No. 4 flat brush and French Ultramarine. The distant horizon was then painted using French Ultramarine, Cadmium Orange and white. I used pure white to paint the sunlit sides of the fishing huts, adding a little French Ultramarine and Cadmium Orange for the shadow side.

▶ STEP THREE

Then I painted the trees alongside the fishing huts, using Viridian and Raw Sienna. With the horizon line established, I painted in the sky with a No. 10 flat brush, with a mix of Coeruleum and white. This was done by starting at the top of the canvas with the strongest blue tone, adding more white and a little Alizarin Crimson towards the horizon. Fast, scrubby brushstrokes created a sense of movement within the sky without the need to paint clearly defined clouds.

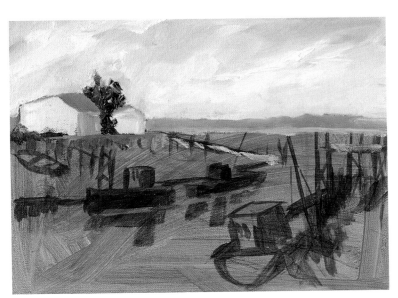

◀ STEP FOUR

Now to paint the boats. I started with simple block shapes for the two smaller boats, using a No. 4 flat brush and pure white paint for the highlights, adding French Ultramarine and Cadmium Orange for the shadow sides. The foreground boat was treated in exactly the same way, only the shapes are different. I mixed a basic green shade for the hull using Viridian, Cadmium Orange and white.

▶ **STEP FIVE**

Still working with the No. 4 flat brush, I used the grey shadow tone to paint in reflected block shapes for the two boats in the middle, using downward brushstrokes only. Next I painted the mud bank with Raw Sienna, Cadmium Orange and white with a No. 8 flat brush. The foreground grassy bank was produced with Sap Green, Light Red and Raw Sienna, adding in the jetty poles.

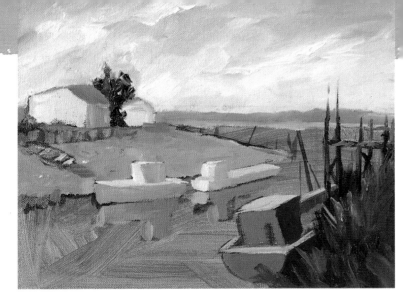

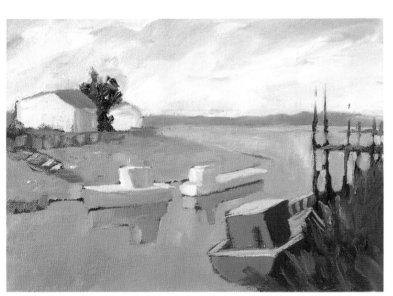

◀ **STEP SIX**

Now for the water. I mixed Coeruleum and a little Lemon Yellow with white. Using the No. 8 flat brush as much as possible I painted the whole area of the water, changing to a No. 4 flat brush to paint in between the jetty poles. I produced this flat area of colour using downward brushstrokes only. All the surface ripples would be added later on.

▶ **STEP SEVEN**

At last I could start to add some details. Using a No. 4 rigger brush with Light Red and French Ultramarine, I started to paint in the jetty and poles on the far bank as well as re-stating those in the foreground. Using a No. 4 round brush I painted the door on the main fishing hut with Coeruleum. On the middle boats I painted one cabin with Coeruleum and the other with Viridian and mixed a grey tone using French Ultramarine, Cadmium Orange and white for the windows. Each boat has a stripe along the top edge of the hull and grey fenders hanging down the side.

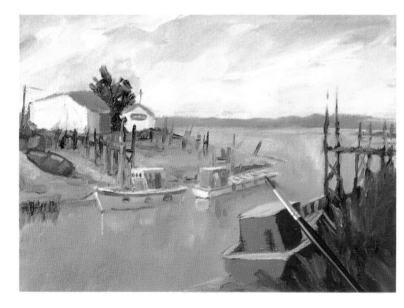

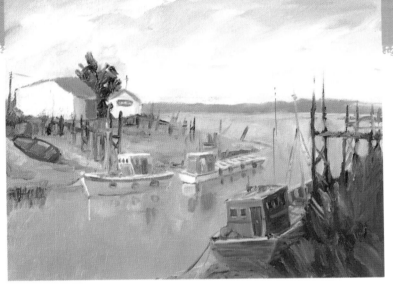

◀ **STEP EIGHT**

I painted the foreground fishing boat in exactly the same way. Now the surface ripples could be added to the water. These were produced with a No. 4 round brush with a little Coeruleum and white gently dragged in horizontal lines over the wet surface. Finally (*see below*), I added two yachts sailing close to the far horizon.

▼ **Oyster Boats, Ile de Ré** 25 x 30 cm (10 x 12 in)

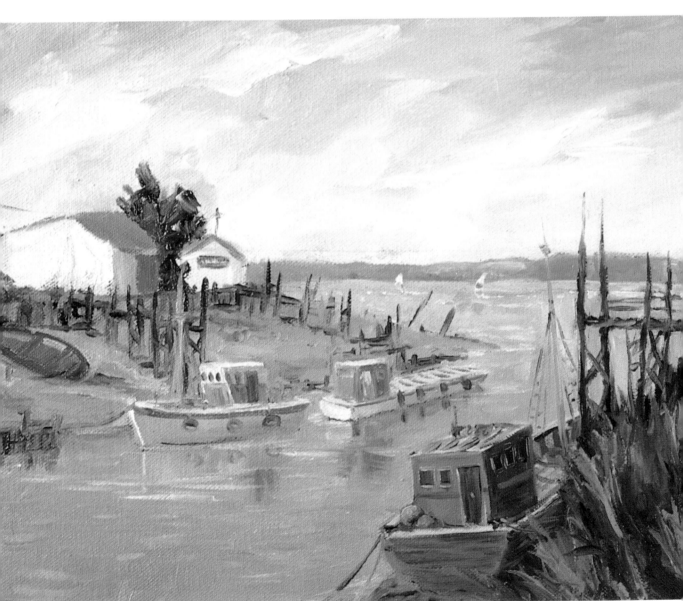

Painting on Location

Trying to capture the many moods of the landscape, from the warmth of a summer's day, through the wonderful colours of autumn, to the bright chill of the first snowfall – these are the elements that excite me about painting outdoors. I hope to dispel any concerns about changing conditions and queries about necessary equipment so that you can enjoy painting outdoors as much as I do.

◄ **Paradise Beach, Meganissi**
25 x 31 cm (10 x 12 in)

▲ Melanie Cambridge
painting on location, France.

▼ **Across the Kentish
Weald**
25 x 31 cm (10 x 12 in)
It started to rain heavily, so
having blocked in the main
areas of the picture I finished
this painting in the studio.

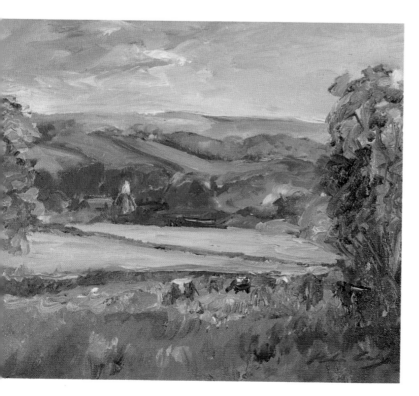

ESSENTIAL EQUIPMENT

Many students claim they cannot
possibly paint outdoors because they
need so much equipment and it is all far
too heavy to carry. Here is how to avoid
being weighed down when taking oil
paints out on location.

If possible, use a pochade box. This
will enable you to carry sufficient paint,
a wet palette, brushes and a small canvas
board all in one box.

Do not take any turpentine, just a
small bottle of alkyd medium and a few
rags. Oil brushes do not dry out
immediately, so they can easily wait until
the evening before being properly
cleaned back in the studio. Simply
wiping off excess paint will be fine while
you are working.

If you take an easel make sure it is a
lightweight wooden sketching easel
rather than a metal one. On breezy days
you can always weight this down with a
stone or log and it is useful to have
already attached a piece of string to the
easel for this purpose.

Canvas boards are ideal for use
outdoors. Being solid, light cannot shine
through from the back. If you wish to use
a stretched canvas, place cardboard
behind it to cut out any backlighting.

COPING WITH THE
ELEMENTS

Even on warm, sunny days if you are
sitting still for a couple of hours or so it
is very easy to start to feel cold and, once
chill starts to set in, any hope of a
successful painting is usually over for the
day. Several layers of clothing is probably
the best solution for outdoor painting,
including a wind and waterproof top
layer to keep out the draughts. A hat is
obviously another important item; in
summer a straw one or at least
something with a large peak to keep the
sun out of the eyes is useful, while in

winter you will need something that covers the ears.

Other items always in my paintbox are sunscreen, insect repellent and a sting-relief spray for insect bites.

SETTING A TIMESCALE

Light conditions are changing all the time outdoors. The sun will move considerably in two to three hours, so try to complete each painting within a two-hour timescale. This need not be as intimidating as it first seems. To start with, work on a small scale, say 25 x 20 cm (10 x 8 in), and concentrate on getting the key elements of the painting down straightaway. Mark in all the shadows and highlights at a very early stage and stick to these, even though they will move as the sun moves across the sky. If there is a complicated building make a sketch of this, noting positions of windows, details of chimneys etc. Even take a photograph if this will help you. Details can always be added back at the studio, leaving time on location to block in the main areas while light conditions remain constant.

WORKING IN A BUSY LOCATION

Working in a busy location can bring its own problems. Few artists enjoy being surrounded by curious onlookers as this can break up your concentration and often results in a disappointing painting.

Sitting with your back to a wall should prevent people from standing behind you, although this will not stop people from talking. Some artists choose

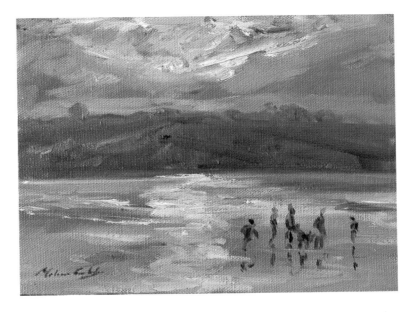

simply to ignore any conversation, making the occasional grunt, but really not answering. However, you may find it better to respond to enquiry, then politely say 'If you don't mind, I do need to concentrate on this bit'. Most onlookers are merely interested and should be happy to leave you alone to work rather than upset your concentration, particularly if nicely asked. The only other solution is to keep away from busy places!

▲ **Sunset, Daymer Bay**
13 x 18 cm (5 x 7 in)
This sunset was painted on location in half an hour using a 15 x 20 cm (6 x 8 in) canvas. Details are very loose and the foreground figures have been reduced to simple silhouettes.

▼ **Camel Estuary**
13 x 18 cm (5 x 7 in)
Painted looking into the light, details were lost, but the highlights on the bridge and distant hills give this picture a great deal of atmosphere.

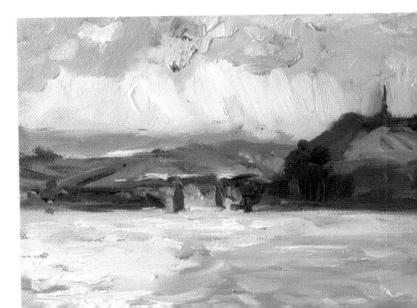

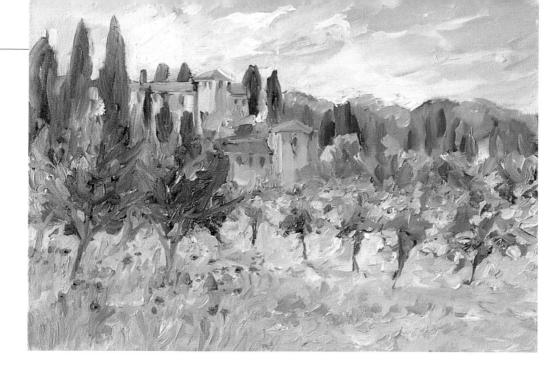

▶ Tuscan Villa
31 x 41 cm (12 x 16 in)
When working abroad you
will find that the light and
colours can be very
different from your usual
palette, so take time to
observe these before you
start painting.

TRAVELLING ABROAD

Taking oil paints abroad presents its own
problems, particularly if you are
travelling by air. Obviously it is not
possible to take flammable liquids such
as turpentine or white spirit onto
aircraft, or to transport wet oil paintings
in a suitcase. One solution is to use fast-
drying alkyd oils and medium. Not only
can these be taken on aircraft (though
not as hand baggage), but when used on
their own they will dry within one or

two days. Instead of trying to obtain
white spirit when you arrive, take a pot
of soap cleaner. This is often sold as
brush restorer for acrylics, but it cleans
oils from brushes just as effectively. You
simply wet the surface of the soap and
work into the bristles and then rinse
with water.

SELECTING YOUR SPOT

When you arrive in a new location the
choice of subjects can be dazzling. Spend
the first day wandering around, taking in
the sights and atmosphere. Make quick
sketches of whatever catches your eye,
from a simple doorway to figures at a
café table or a view of a distant hilltop. It
is a good idea not to take a camera on
this first day as it can be too tempting
simply to take lots of photographs and
avoid any sketching. Although
photographs are useful for general
reference material, rapid sketches with a
few scribbled colour notes often bring
back more accurate and personal
memories of a scene.

▶ As well as enjoying
painting on location, try to
find time to sketch, even if
the results are as rough as
this one – produced while
waiting for the ferry!

Having found a suitable spot to paint, preferably in the shade and with your back to a wall to avoid too many interruptions, spend a few moments assessing the scene in front of you. Colours may be stronger than you are used to. Sunlight can bleach out pavements and stonework to almost pure white. In hotter climates you may prefer to work on a white canvas to keep the colours pure. Alternatively, Alizarin Crimson makes a cooler undertone, so it is a matter of experimenting to find what works best for you.

Work on a small scale and try to produce a morning and afternoon painting. Concentrate on blocking in the main shapes and establishing areas of light and shade. Make notes of any special details in your sketchbook and take a few photographs as extra reference material before you leave.

BACK AT THE STUDIO

When you return from a painting trip, put all of your paintings to one side to look at again in two or three days' time. This will avoid feelings of disappointment. I often find that if I look critically at my work as soon as I return to the studio, with the outdoor image still fresh in my mind, I feel disappointed with the results. This is because I am not looking at the painting as a painting, but instead judging it against the outdoor scene. After a couple of days it becomes easier to consider the paintings critically in their own right, so that is the time to consider making any minor changes or improvements.

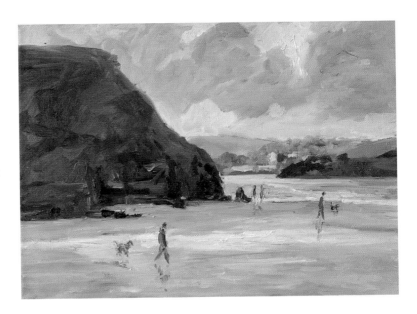

▼ **Daymer Bay, Cornwall – as painted on location**
30 x 41 cm (12 x 16 in)
Painted in just over one hour on a cold, clear afternoon in December.

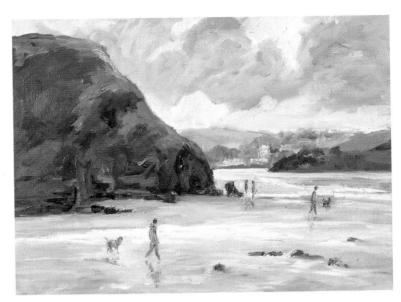

▲ **Daymer Bay, Cornwall – back at the studio**
30 x 41 cm (12 x 16 in)
Highlights to the foreground cliff helped to give it more shape, while extra stones on the beach lead the eye into the painting.

demonstration
Morning Light, Kefallonia

The village of Assos nestles at the bottom of a steep cliff on the Greek Island of Kefallonia and made an enticing subject in the clear morning light. Having settled on a stone wall at the end of the quay, I decided to use the steep hillside as a backdrop rather than looking out to sea. The light was strong, even early in the morning, so I chose to paint directly onto white canvas to keep the colours cooler.

you will need

canvas 35 x 40 cm (14 x 16 in)
brushes: No. 8 short flat, No. 4 short flat, No. 4 round, No. 10 short flat

colours

French Ultramarine, Cadmium Orange, Yellow Ochre, Viridian, Coeruleum, Sap Green, Lemon Yellow, Light Red, Alizarin Crimson and Titanium White.

tips

◆ *Keep the brushstrokes fluid to create the effect of woodland rather than individual tree shapes.*

◆ *Use angled brushmarks to give a three-dimensional shape to the olive trees.*

◆ *Use light pressure on the brush for the reflections in the water to avoid muddying the paint underneath.*

◆ *Adding stripes to the fisherman's top helps to make him look more three-dimensional.*

◆ *Keep window details simple for buildings on the hillside to maintain a sense of depth.*

◆ *Darken the foreground shadows to make the sunlit quay appear brighter.*

▲ **STEP ONE**

Before starting to paint I made a sketch of the scene and a separate note of the fisherman sorting his nets. Working on location can present problems for the artist; figures tend to come and go and there was also the chance that the boat I hoped to make the centre of interest would disappear before I had finished painting it.

◀ STEP TWO

Putting the sketch to one side, I blocked in the scene with a No. 4 flat brush using French Ultramarine. The side of the café is a solid blue and the shadow underneath the café awning was also marked in at this stage.

▶ STEP THREE

Using the No. 8 flat brush I started to block in the background hillside. I started at the top of the canvas, mixing Viridian, Coeruleum and white for the pale mint green shades. Yellow Ochre was added to this mix for warmer green tones lower down. I left the four middle-ground trees at this stage.

◀ STEP FOUR

Switching to a No 4 flat brush, I blocked in the buildings on the far side of the bay with a mix of Yellow Ochre, Coeruleum and white, with Cadmium Orange and Coeruleum for the roofs. Windows were marked in with a No. 4 round brush, using French Ultramarine and Cadmium Orange. Using a No. 8 flat brush, I painted the large tree on the right-hand side with Sap Green and Yellow Ochre, while the olive trees in front are a mix of Viridian and Cadmium Orange.

▶ **STEP FIVE**

A No. 10 flat brush loaded with Coeruleum and white was used for the water. I started just beneath the middle building, using flat brushstrokes first of all. Then I held the brush flat against the canvas, dragging it gently over the surface to paint the ripples. More Coeruleum and a very little Lemon Yellow was added to the mix as I worked towards the bottom of the canvas.

◀ **STEP SIX**

With the water finished, I linked the far edge of the water to the shore by painting the shallow beach using Yellow Ochre and white. The low wall that divides the beach from the village was painted in soft grey tones mixed from Coeruleum, Cadmium Orange and white. I blocked in the side of the café with a No. 10 flat brush using Light Red, French Ultramarine and white. The sunlit foreground was produced from Cadmium Orange and Coeruleum with plenty of white added. Then I used a darker version of the same mix for the shadow under the café awning and along the edge of the quay.

▶ **STEP SEVEN**

Using the No. 10 flat brush, I painted the sky with Coeruleum, Cadmium Orange and white. The café awning is white along the top highlight, but I painted the shadow with Light Red and French Ultramarine with plenty of white. The same grey, but much stronger, was used to paint the lamppost. The café chairs are Coeruleum, painted directly over the wet pavement shadow. Underlying grey tones picked up by the No. 4 round brush soften the colours of the chairs.

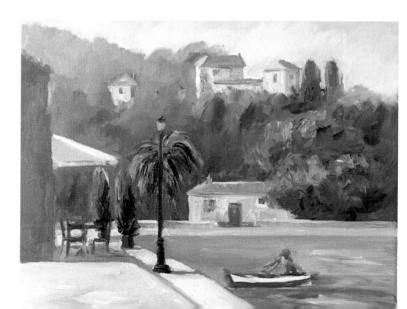

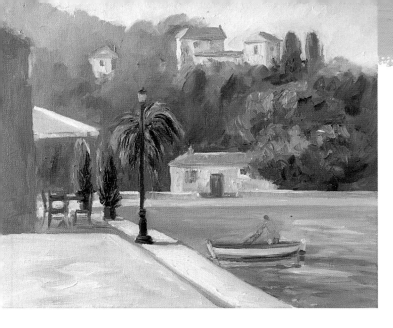

◀ **STEP EIGHT**

I painted the boat hull in horizontal stripes. I also blocked in the fisherman, painting his top and shorts, then adding arms, legs and head. A few horizontal reflections were added beneath the boat. Finally (*see below*), I added red stripes to the fisherman's jersey and I repainted the café chairs, which appeared too large in proportion to the rest of the painting.

▼ **Morning Light, Kefallonia** 35 x 40 cm (14 x 16 in)

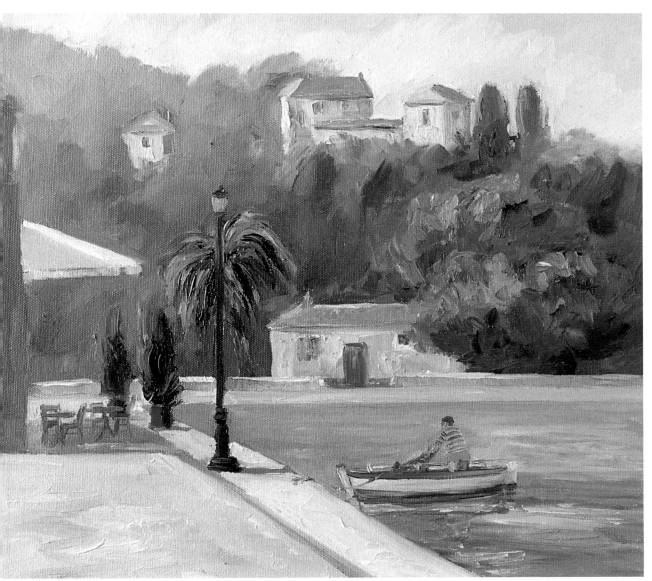

Finishing Touches

Once a painting is completely dry, usually after about a month, it should be varnished. I would recommend just one coat of retouching varnish, applied with a soft brush. As oil paint dries out dull patches can appear on the surface, caused by some of the paint sinking into the canvas. By varnishing your paintings these dull patches are covered over. The varnish also 'brings back to life' those darker areas where some of the subtle changes in tones may have been lost. Try it and see; you will be surprised just how much better your painting appears once it has been varnished.

To show off your finished painting to best advantage it needs to be framed. Unlike watercolours, oil paintings are not usually framed under glass, so the frame itself tends to be somewhat larger. Even for a small painting, say 25 x 30 cm (10 x 12 in), I prefer to use at least a 5 cm (2 in) wide frame, with an inner slip moulding. An inner slip moulding provides a visual breathing space between the painting and the frame (rather like a mount does for watercolours). The frame itself should complement the colours of the painting rather than be too dominant.

▶ **Sunset over Romney Marsh**
28 x 36 cm (11 x 14 in)
Smaller paintings can often look very good with quite a large frame. This one is 5 cm (2 in) wide.

◀ **Fishing Huts, Ile de Ré**
25 x 30 cm (10 x 12 in)
Using an inner slip frame
provides a separation line
between the frame and the
painting. The sloping shape
of the frame also helps to
guide the viewer's eye
towards the painting.

EXHIBITING YOUR WORK

Most artists from time to time wish to
exhibit their work. For the first-time
exhibitor the opportunity can often be
through a local art society, most of which
hold annual exhibitions for their
members. The more ambitious might
consider submitting work to the various
open exhibitions and national
competitions run by the major art
societies. These exhibitions certainly
provide an excellent indicator of an
artist's progress and give you something
to aim for. However, the selection process
is very severe, so to have a piece accepted
is a tremendous achievement in itself.

Most commercial galleries are happy
to look at new work, but it is courteous
to make an appointment. It is worth
visiting any potential galleries
beforehand both to check out the type of
work on display and to see whether your
own work might fit in with the gallery's
image. However, you need a broad back
to cope with rejection time and again.

Another way to present your work to
the public is by taking part in one of the
many art fairs around the country.
Usually space is limited and you will
need to book a spot in advance. The thrill
of having your own work on display as
well as meeting and talking to people
who are interested in your work is a
great boost to morale. Should you sell a
painting, then all the hard work and
preparation are suddenly worthwhile!

Jargon Buster

ALLA PRIMA Meaning 'at the first'. Used to describe an oil painting produced in one painting session, worked entirely wet-in-wet.

BODY COLOUR Describes any colour when mixed with white. Adding white changes the paint's characteristics slightly, making it more opaque (*far right*).

COLOUR TEMPERATURE Describes how warm or cool a colour is. Red, yellow and orange are generally warm colours, whereas blue, green and violet are cooler. However, each colour has its own degree of warmth or coolness; for example, Cadmium Red is warm, but Alizarin Crimson is a cooler red.

COMPLEMENTARY COLOURS Each complementary colour is created by mixing the two other primaries together. For example: red's complementary is green (that is, blue and yellow mixed together). Similarly, blue's complementary is orange; yellow's complementary is purple.

EN PLEIN AIR Describes a painting produced 'in the open air' (that is, painted outdoors on location).

'FAT OVER LEAN' When painting with a traditional oil and spirit medium, it is necessary to start with a mainly spirit-based medium and gradually add more oil as the painting progresses. This is to prevent cracking of the later layers of oil paint (see 'oiling out'). Lean refers to the thin spirit-based medium; Fat refers to the thicker more oily medium that is applied later – never the other way round. Using a commercially made alkyd medium rather than mixing your own avoids this potential difficulty.

GLAZING Thin layers of paint applied over an already dry oil painting. Colours may be mixed with retouching varnish to create a translucent layer. Glazes are a useful method of unifying a badly coloured painting or enhancing one particular area.

GROUND The surface on which the painting is actually made. Often a toned or coloured ground is applied on top of the initial primer coat, using a thin 'turpsy' wash of Raw Sienna or other earth colour.

LOCAL COLOUR This is the true colour of an object: for example, a blue ball or red towel. This local colour, however, is affected both by light and its surroundings. A blue ball lit by a bright spotlight, although actually blue all over, appears much lighter where the spotlight catches the top and similarly much darker on the shadow side. The local colour, blue, is changed by the light. These lighter and darker areas are known as the tonal colour.

MAHLSTICK A fairly long stick with a leather- or cloth-covered knob at one end, used to steady the wrist while painting details.

MEDIUM Traditionally this referred to the paint itself. However, the term is also used to describe the thinning liquid or gel mixed with oil paint to thin and blend colours together.

OILING OUT As oil paint dries out underlying layers can suck oil from the top layer of paint, causing it to crack. Wiping a thin layer of linseed oil onto the surface of a touch-dry painting (with cotton wool or a soft brush) feeds the top surface of paint and thus protects it from cracking.

PRIMER The initial coat applied to raw canvas to create a suitable painting surface. This may be gesso primer or a modern acrylic primer. It is also possible to use household emulsion on hardboard or wood to create a suitable surface for oil paint.

TONAL KEY Generally used to describe the overall lightness or darkness of a painting. For example, a bright beach scene full of light and bright colours would be regarded as 'high key', whereas a soft evening landscape might be termed 'low key'.

TONKING Laying newsprint over the wet surface of a painting in order to remove the top layer of paint. Press down gently on the paper and then peel back. This technique was popular with the Impressionists.

Index
Page numbers in *italic* refer to captions